PCPhoto

BEST TIPS & TECHNIQUES

Digital Photography

D0278240

700029129277

LARK BOOKS

A Division of Sterling Publishing Co., Inc.

New York

Editor: Peter K. Burian
Design & Layout: Mimi Netzel
Cover Design: Jon Fahnestock

Library of Congress Cataloging-in-Publication Data

PCPhoto best tips & techniques for digital photography / Werner Publishing Corporation.
 p. cm.
 Includes index.
 ISBN 1-57990-697-4 (pbk.)
 1. Photography—Digital techniques. I. Werner F
Title: PCPhoto best tips and techniques for digital
TR267.P38 2006
775—dc22
 2005010

10 9 8 7 6 5 4 3 2 1
First Edition

Published by Lark Books, A Division of
Sterling Publishing Co., Inc.
387 Park Avenue South, New York, N.Y. 10016

Distributed in Canada by Sterling Publishing,
c/o Canadian Manda Group, 165 Dufferin Street
Toronto, Ontario, Canada M6K 3H6

Distributed in the U.K. by Guild of Master Craftsman Publications Ltd.,
Castle Place, 166 High Street, Lewes, East Sussex, England BN7 1XU
Tel: (+ 44) 1273 477374, Fax: (+ 44) 1273 478606,
Email: pubs@thegmcgroup.com; Web: www.gmcpublications.com

Distributed in Australia by Capricorn Link (Australia) Pty Ltd.,
P.O. Box 704, Windsor, NSW 2756 Australia

If you have questions or comments about this book, please contact:
Lark Books, 67 Broadway, Asheville, NC 28801, (828) 253-0467

Manufactured in China
All rights reserved
ISBN 1-57990-697-4

For information about custom editions, special sales, premium and corporate purchases, please
contact Sterling Special Sales Department at 800-805-5489 or specialsales@sterlingpub.com.

contents

preface

Photographers were a little suspicious about digital photography when *PCPhoto Magazine* first came out in 1997. The digital cameras of that time were not comparable to film, yet manufacturers hyped them as if they were. Pro cameras cost well over $10,000. Scanners were in their prime and desktop printers were just beginning to show what they could do.

A few years back, I'd go to photography meetings and most of the group was looking down on digital, saying it would never match film and they'd never go to digital. Now, what a difference! I have actually had people come up to me and apologize for not going digital. That's a little silly, perhaps, but it demonstrates how prevalent digital has become. Digital camera sales are booming and everyone has or wants one. At a recent event for Disneyland, a news photographer photographed a line of people at the gate taking their first "official" pictures, and nearly all were using a digital camera.

This book is a compilation of the writings of the *PCPhoto* editors. In it, we offer you specific ideas on how to choose and use gear within a given category, as well as examples of equipment so that you can compare features, size, and appearance. We've also included lots of how-to information to encourage you to go out and take more pictures.

Taking more photos, getting out and shooting, trying new ideas—these are all exciting parts of digital photography. Again and again we hear that photographers are energized by taking pictures digitally. Digital lets people take more photos without worrying about the cost of film and processing; it lets photographers see images immediately on their LCD and offers great opportunities for achieving outstanding, displayable prints that just weren't convenient with film. Digital means more choices and more flexibility which leads to increased fun and creativity for everyone.

Often we are asked for specific recommendations on gear—all in the context of much banter about which camera, lens, bag, scanner, etc., is the "best." Since we don't know enough about an inquiring person's specific needs, these questions can be a challenge to answer. There really is no "best camera" (or any other gear) unless the words are qualified—the "best camera for me." I know you've heard this before, but let me illustrate my point with a little story.

Earlier this year I purchased an excellent little advanced digital camera, we'll call it "camera A." It offered some truly outstanding features and gave superb results, but I never really was comfortable using it. I should have trusted my instincts before I made the purchase, but I was overly influenced by its features.

A friend tried it out and loved it. It did everything he needed, plus he really did like the way it handled and fit his hands. So, he bought camera A from me and I bought a new camera, "camera B." It is interesting to note that my friend had considered camera B as well, but he was not confident it would meet his needs.

So, consider this—the same camera, camera A, was both the "best" and the "worst" camera. I happen to really like camera B because it fits my way of shooting, yet my friend is convinced he got the better deal. So, camera B is also "best" and "worst."

I really believe that the best camera for you, the best computer, the best software, and so forth, is the one that you are comfortable using, the one that has the features you need at a price you can afford. The bottom line is that *PCPhoto* is designed to really help photography be a fun experience and to energize people to enjoy their equipment by using it.

This book covers a whole range of possibilities for digital photography and should have something that can inspire and encourage nearly everyone. Our wish for you is that you go out and have fun with your gear—no matter what it is, what subjects you love to shoot, or what anyone else says about your photos! We love it all!

—Rob Sheppard
　　editor, *PCPhoto Magazine*

introduction to
digital photography

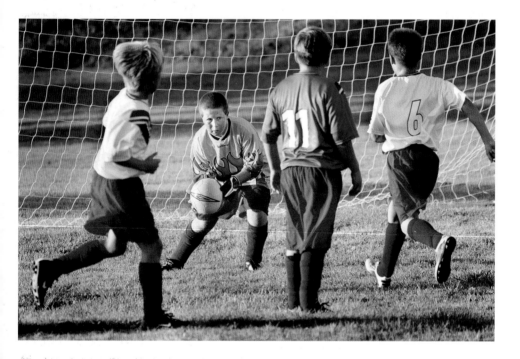

Regardless of the type of camera you use, the basics of picture taking are similar. Naturally, digital cameras include many high tech features not available in film photography, making digital capture more versatile. On the other hand, the unique capabilities and technology can be frustrating until you begin to fully appreciate their meaning and their value.

Throughout this book, you'll find explanations, tips and recommendations. They're intended to help imaging enthusiasts at all levels to become fully conversant with the hardware, the software, the technology and techniques that make digital photography and imaging so rewarding. In this first chapter, we'll consider some basic digital principles and camera features as an introduction to more detailed and more advanced content in the subsequent chapters.

Top Seven Ways Digital is Different

Features from LCD's to white balance give digital cameras unique capabilities not found in traditional equipment.

Text and Photography by Rob Sheppard

Film traditionalists once felt that digital cameras were a distraction that took away from "real" photography. While I like working with film and there are a lot of great reasons to use traditional media, digital cameras offer some distinct advantages. They allow us to take pictures in ways that either can't be done or are difficult to do using traditional methods.

I'm excited about that. For me, the digital camera has opened up whole new enjoyable experiences with photography. I like working with all types of digital cameras, from simple point-and-shoots to high-end digital SLR's. I especially like the very compact and fully capable mid-range units that offer the capabilities of a 35mm SLR without interchangeable lenses.

The digital camera truly expands our photographic possibilities. The LCD monitor, rotating displays, and white balance, plus the ability to review as you photograph, change ISO as you shoot, and more: all greatly affect how we can photograph.

The LCD is a useful tool to check exposure, color, lighting, and composition. It also encourages you to experiment and be creative when shooting.

LCD Monitors

The LCD monitor is one of the great innovations of the digital camera. When you look at the little LCD monitor, it becomes something quite different than an optical viewfinder. What you see is more like a small picture than a sighting device. You can look at that picture and decide if you like it as a photo or not. This is a very different approach to making a photograph.

However, you must realize that what you see with an LCD monitor is not exactly what you'll get in the final print or even on the computer screen. The LCD monitor has a very specific way of displaying the image. For example, you can't see the exact sharpness of the image unless you enlarge it (some cameras allow you to do that on-screen), and colors, tonalities, and contrast aren't precise on the LCD monitor.

Still, I love the connection you get to the scene in front of you when it's translated into a picture on the LCD. To me, this is a wonderful way to see how a scene becomes a photograph. In addition, it allows you to see exactly what you are getting in the picture. Sometimes the optical viewfinder sees less than what's actually captured by the sensor.

The LCD monitor lets you review and edit your images as you shoot. This way you can be sure you get the shots you want.

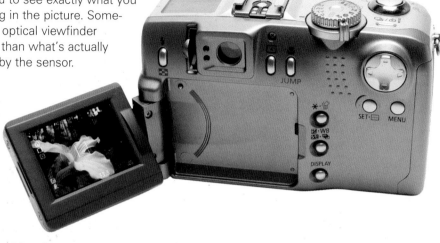

Rotating Monitors

Rotating or swiveling monitors have long been a part of video camcorders. Right now they can be found in some Nikon, Canon, and Olympus cameras. It's interesting that when rotating monitors first came out, a lot of people thought these were only gimmicks. Well, they aren't. The rotating monitor is a tremendous tool for the photographer. Here are some ways it can help:

1. **High-angle shots**—There are situations where getting a higher angle on the subject can give you better composition. Or maybe you're photographing a parade or other situation where people are between you and your subject, so you have to photograph over them. The rotating monitor allows you to hold the camera overhead and still be able to see what your lens is seeing.

2. **Awkward shots**—Sometimes we get stuck in a location where we can't easily get back far enough to get everything we want into our photograph. For example, you need to photograph in a room and the best spot is right in a corner. With a rotating monitor, you can stick that camera right up in the corner while you tuck yourself as close to it as you can, using the monitor to see your composition.

Can't see over the crowd? Hold the camera high and tip the LCD down so you can compose your photos.

It would be awkward to use the viewfinder or even an LCD monitor on the camera back with the camera positioned this low to the ground

A rotating monitor can help you take a picture of a camera-shy subject.

3. **Extreme low-angle shots**—Unusual angles can be a great way of gaining a viewer's attention for your photographs. With a rotating LCD screen, you can literally put the camera right on the ground, even in a hole if you want, and comfortably sit or kneel by the camera.

4. **Easier close-ups**—There are times when you're making a close-up and it becomes difficult to get your whole body and camera close to the subject. With a rotating monitor, you can position the camera so that it's in the best place for the photograph and tilt the LCD monitor so you can still see the screen comfortably.

5. **Unobtrusive shots**—Point the camera right at somebody and they react to it—sometimes well, sometimes not. If you can face away from the subject and still see him or her with your camera's lens, you can sometimes get nice candid shots. You can easily do this with a swiveling monitor by pointing the camera at the subject while you face at a 90-degree angle to him or her. Then, swivel the monitor so you can see the composition on the LCD screen.

Backlighting can be tricky. Fortunately, with a digital camera, you can review each shot and make corrections as needed. In this case, flash was added to illuminate the foreground.

Review as You Shoot

I love the ability to review and check my shots as I go. Sometimes when I see that picture I just shot on the LCD screen and it isn't moving like it does when I'm preparing to take the picture, it looks a little different than expected. I often decide that I need a different composition. This ability to review images encourages me to be more creative.

The LCD monitor also helps you confirm that your exposure is correct. Just realize that the monitor won't give you a perfect rendition of your real exposure. You need to take some pictures, see what they look like in your computer and compare them

to what you see on the LCD monitor to really be able to interpret this. Still, the LCD gives you an approximation of what your exposure is going to be. If your camera includes histograms, learn to use them, as they'll help you determine best exposures.

It's certainly nice that you can see any problems while you're photographing— now you have a chance to correct them. It's always a big disappointment when you get home, look at pictures as they come back from the processor, and see instantly how they might have been improved. At that point, you can't redo the picture because you're long gone from your subject's location.

White Balance

White balance is a very important part of every digital camera. Your camera has to know how to deal with the various colors of light that are all around us. Fluorescent light, sunlight, and shade all give different color renditions.

In the past, we had to make those corrections with filters to make the colors look right on film (or you'd have to use a film with a specific color balance). With the digital camera, we can affect how the camera sees the color of light through "white balance," a way the camera looks at light and corrects the colors to make white appear white.

On some of the very low-end cameras, white balance is only an automatic feature. However, most digital cameras allow you to actually set white balance. At the minimum, you'll likely be able to set the white balance to sun, clouds or indoors. In many cameras, you can actually set it to a variety of indoor settings, including fluorescent, and you may even be able to use a custom setting to precisely adjust the white balance to an exact condition.

This makes white balance both a corrective tool and a creative tool. Try different white balance settings. You can see the effects in the LCD monitor. You may discover that you like a certain setting better than what might be the expected setting.

Auto White Balance

Cloudy White Balance

Incandescent White Balance

Fluorescent White Balance

In bright sunlight, use a low ISO setting and at night switch to a high ISO setting. With a digital camera, the ISO can be adjusted from shot to shot.

Changing ISO

The ISO of film refers to a rated speed or sensitivity of film to light. High numbers give you high speeds and more sensitivity; low numbers give you lower speeds and less sensitivity. In addition, high-speed films tend to be grainier than low-speed films, while low-speed films have the best sharpness and color qualities. For highest quality, lower-speed films are usually chosen. When you need a faster shutter speed or to shoot in low light, you choose a high-speed film. Unfortunately, it isn't always easy to change film when needed to adapt to changing conditions.

Technically, digital cameras don't have an ISO rating. However, they do have an ISO equivalent that effectively works much like film speeds. So a digital camera's ISO settings can be adjusted for high and low sensitivity.

And the camera doesn't have to be opened to change films. You can actually change ISO settings while you're shooting. You can take a picture with a high-speed setting for an indoor shot, then change the camera to a low-speed, high-quality setting when you go outside. You can alternate settings as much as you want. This really offers a lot of flexibility.

Revise and Edit

It's rare that you'll run into a situation in which you can get a single picture that will totally capture the setting. Usually, you'll take multiple pictures because you want to try different exposures or compositions, or you're photographing things that are changing because of action, wind, weather, etc. Not all of those pictures are going to be your best.

I like to edit these pictures as I go; in other words, remove pictures that really aren't what I like or want. I believe you get a better set of photographs in the end. However, there's more to it than simply removing the bad stuff. As you edit your pictures, you'll discover what's working and not working for you in that particular situation. This allows you to adjust your shooting as you go—and you get better pictures.

In addition, as you look at your pictures, you'll see where you've missed shots or where you need to compose from different angles. Then, take those pictures while you're still at your location! You couldn't do that if you didn't edit during your photography.

Explore various ways of presenting your subject. By trying several compositions, you may find a better photograph than the one you originally intended.

Standards to Know

Understanding these basic principles will improve your digital photographs.

Text And Photography By Ibarionex R. Perello

Digital photography involves more than just buying a camera and a computer. Understanding the fundamentals of digital photography is what allows us to really take full advantage of the technology in which we've invested.

Luckily, these concepts don't require a master's degree in quantum physics. That's why we've compiled a list of definitions and basic rules that you need to know. So whether you intend your images for a Website or plan to print your own enlargements, this information will make your venture into digital photography an easier one.

What Is a Megapixel?

A pixel in a digital camera is much like grain in a traditional frame of film. They're both designed to be sensitive to light and are the building blocks from which the final image is created.

An acronym for picture elements, pixels are found on the CCD (charged coupled device) or CMOS (complementary metal oxide semiconductor) microchip that's used as the sensor in digital cameras. The greater the number of pixels on the sensor, the higher the resolution of the camera.

A megapixel is equal to a million pixels. For example, a 5MP (five million pixels) camera provides more resolution than a camera with a 3MP (three million pixels) chip. The increase in pixels means that the camera will not only be able to better capture fine details, but it will also allow you to create bigger enlargements while maintaining image quality. In subsequent chapters, we'll provide some rules of thumb as to how many megapixels you need for a high-quality print of certain sizes.

However, most new compact digital cameras offer at least 4MP resolution, and that's certainly adequate for making a nice 8 x 10-inch (20 x 25-cm) print. The digital SLR cameras typically offer at least 5MP, and usually 6MP resolution or larger, adequate for superb 11 x 14-inch (28 x 35-cm) prints. Your technically best high-resolution images should make for very good 13 x 19-inch (33 x 48-cm) prints, the largest possible with consumer-grade photo printers. If you use an 8MP digital SLR, and if you optimize the images for printing with some expertise, you should be able to get good 16 x 20-inch (41 x 51-cm) prints from a pro lab.

By comparison, a 35mm negative will provide an excellent 11 x 14-inch (28 x 35-cm) print, while at 16 x 20 inches (41 x 51 cm) or larger, the grain pattern of the film becomes more obvious in the image and loses the ability to produce "seamless" tonal transitions. Though digital has yet to rival film for image resolution—unless you use one of the 12+ MP pro cameras—the resulting prints compare favorably to those made from 35mm film.

How Much Storage Capacity Do I Need?

Depending on the manufacturer, images will be stored on one of several types of memory cards, such as the CompactFlash or SD format. The capacities of these cards vary from as little as 8 megabytes (MB) to as high as 8 gigabytes (GB) and up with some card formats. While most digital cameras come with a small capacity card, you'll want to invest in a larger memory card. The greater the resolution of your camera, the greater your need for a large-capacity media card.

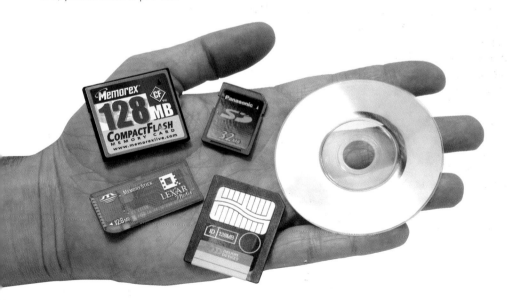

You can maximize space by selecting a low resolution setting in your camera or a low quality (high JPEG compression) setting. The resulting files will be small but you won't get the high quality that your camera is capable of producing. In general, it's a good idea to purchase as large a capacity card as you can afford: at least 512MB with a 5+ megapixel camera. If your photographs are destined solely for email or a website, you may plan to use only low resolution/low quality settings when shooting. That tactic is certainly fine if you have no other use for the images. In that case, you don't really need maximum image quality and do not require a huge-capacity card.

How Do I Get Images From Media Into My Computer?

Digital cameras all offer the means to download images directly from the camera to the computer using a USB interface: a USB cable (usually included with the camera) plugged into a USB port on the computer. This is the most straightforward way to download data and it's easy as well.

There's an alternative method: the card reader accessory. Connected to your computer via a parallel, USB, or FireWire (IEEE 1394) cable, card readers accept your media card directly. That eliminates the need for constantly plugging in your camera and later unplugging it. This allows you the freedom to use the camera while images are being downloaded, and also reduces battery drain as the camera doesn't have to be on and active while the download takes place. Simply remove the memory card from the camera and slide it into the reader.

Card readers are a quick and easy way to download image files into your computer.

What File Format Should I Choose?

When you take a picture using a digital camera, it's saved on a media card in one of several image file formats. Most cameras record in the JPEG (Joint Photographic Experts Group) format. A few cameras include an additional option to record in TIFF (Tagged Image File Format), while an increasing number of high-end models also include a RAW format option (raw data direct from the camera's sensor).

JPEG: This format is ideal for use in a digital camera because it significantly compresses image files, using mathematical algorithms. That means we can save a lot of images to our memory cards. Problem is, JPEG uses "lossy" compression, which means that information is removed or "lost" in order to achieve a smaller file size. That's not really a problem as long as you use the best available JPEG options; often called Large/Fine, Large/Super Fine, or simply Best, depending on your model of camera. These choices usually produce the best possible image quality in a JPEG.

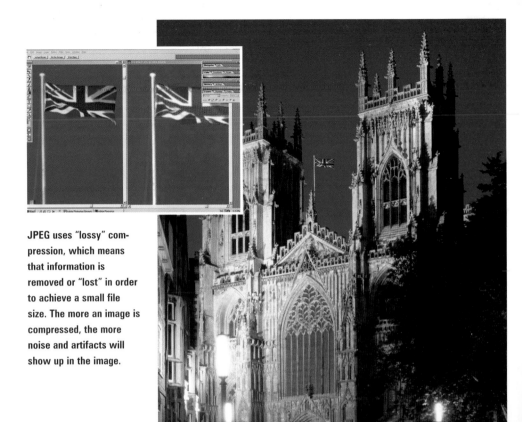

JPEG uses "lossy" compression, which means that information is removed or "lost" in order to achieve a small file size. The more an image is compressed, the more noise and artifacts will show up in the image.

How many images can you save on a memory card? That depends on card capacity and your choice of the file size and quality option. The lesser-quality mode will compress the image more, but at a loss of quality, as some information is discarded in order to achieve the smaller file size.

TIFF: A less common capture mode, this one produces TIFF format files that are not compressed, so the files are substantially larger. Image quality may be slightly higher than in a JPEG, but because the files are larger than JPEG, the time required to record images to a memory card is longer, and that can be frustrating. The TIFF option may be fine for landscapes when you're not in a hurry and have high-capacity memory cards, but it's less useful for most other subjects.

RAW: Some cameras can record raw data in a proprietary RAW format; these files may be slightly compressed or not at all compressed. The camera's processor does not enhance (sharpen, boost saturation, etc.) the image in-camera. The file size of images saved in this format is much larger than JPEG's, so fewer images will be stored on a media card. Do note however that special software (packaged with the camera) is required to convert a RAW file to an image file. That can be complicated and time consuming but allows you to make major changes— before the image is processed and converted to a familiar format—without seriously affecting image quality.

How Do I Choose Output Resolution?

When you take a digital photograph, the resulting file has the potential to be used in a variety of ways. You can create a print, email the photo, or use it as an illustration for your Web page. However, the image file as produced by the camera isn't automatically ready for print or the Web. An original file when imported into an image-processing program comes in at a native resolution of 72 dpi, often at a size of well over 20 x 24 inches (51 x 61 cm). That combination isn't appropriate for printing or for email; changes need to be made.

Before you get anxious about having to find your old slide rule, you can follow some basic recommendations for converting the original file to the appropriate resolution and file size. These changes can be made in your image-processing software, using a Size or Resize feature.

For purposes of a website or for email, the file size can be relatively small. At a resolution of 72 dpi and a size of 4 x 6 inches (10 x 15 cm), an image can be approximately 365K; the file size will be substantially smaller when compressed and saved as a JPEG in your image-processing software. This will provide a good-quality image for use on the Web or for email. Attempting to use files that are considerably larger won't result in better image quality, but will increase the time needed to download the image from an email or to render a web page.

A larger file size is appropriate when it's time to make a print. At a resolution of 240 to 300 ppi (pixels per inch), a 4 x 6-inch (10 x 15-cm) color image file will be approximately 4 to 6MB in size. (Note that ppi is also called dpi often; while that's not technically correct when discussing image resolution, it has become common usage.) At the same resolution, an 11 x 17-inch (28 x 43-cm) print will result in a file size of 34 to 40MB.

A printer's resolution may be as high as 2880 dpi, but there's no need to set your image file's resolution to that same

Using Adobe Photoshop, the image dimensions and image resolution are set using the Image Size function.

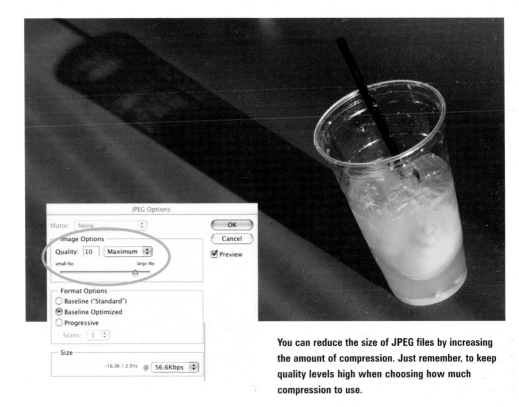

You can reduce the size of JPEG files by increasing the amount of compression. Just remember, to keep quality levels high when choosing how much compression to use.

number. If you did, image quality would actually suffer rather than improve. Printer resolution—abbreviated as dpi—is quite different than image resolution. The printer dpi reflects the applications of ink dots to paper and has nothing to do with the resolution of the original photo. The camera resolution speaks to the number of pixels inherent to the sensor that captures the picture, e.g., a 3-megapixel camera may produce a 2048 x 1536 pixel image.

When you save these image files, you can use a JPEG format that will compress the existing file into a much smaller one. This is ideal for not only conserving space on your hard drive, but also for speeding up the time needed to upload/download the image for email.

JPEG allows for various degrees of compression. The more compression is applied, the more data is discarded to achieve the smaller size. For maximum

quality, choose the highest setting in image-processing software for minimal data loss. For email or website use, a moderate compression will still provide a good-quality image. However, we recommend that you not repeatedly edit and save the image as a JPEG because the data loss will be cumulative. Convert your images to the TIFF format instead in the computer.

Practice and Experiment

Although we recommend applying these guidelines, we encourage you to experiment. With practice and a little experimentation, you'll not only gain a better understanding of digital photography, but you'll also learn what works better for you. You'll become adept at using these new tools, and you'll feel confident in using them for capturing images of your world.

digital camera features

In Chapter 1 we discussed some essential concepts that are well worth understanding as you read the subsequent chapters. Now let's take a look at some typical digital camera features before moving on to review specific types of cameras and some of the more advanced capabilities.

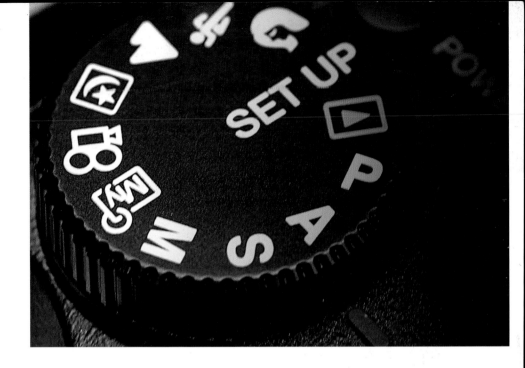

Your Guide To Camera Modes

Take better images more easily with your digital camera's programmed settings and other modes.

By Wes Pitts

While scanning the specifications for a new digital camera, you may ask yourself, "Who needs all these modes?" That's understandable, especially if you were previously using a 35mm camera with a lot fewer options.

A fully automatic Program mode, a fully Manual mode, and semi-automatic modes (Aperture Priority and Shutter Priority) have been around for a long time on all types of cameras. Digital cameras, especially recent compact models with built-in lenses, include many new options, each finely tuned for specific shooting situations. Some cameras have more than a dozen of these specialized scene modes: for beach scenes, fireworks, parties, and so on.

The point of these automated modes is not to dumb down the camera. Like Aperture and Shutter Priority settings, the goal is to create quick shortcuts to correct exposures. The subject specific Scene modes offer greater automation however: they set the most suitable aperture/shutter speed for specific types of situations. These Program modes help make photography more enjoyable and successful, bypassing the guesswork, particularly when you need to act quickly in order to catch the shot. They also make your camera more family-friendly so that anyone in the clan can get better results.

One important thing to note about these modes: while they will often provide a good photograph, you may be prevented

from adjusting factors such as exposure, white balance, flash mode, ISO and the like. This is understandable in a Program mode designed to make all of the suitable settings for a specific type of subject. When you use a camera's Manual mode, or semi-automatic Aperture Priority and Shutter Priority modes, you can take advantage of any overrides.

If you ever wonder why you can't change your white-balance setting for example, check the camera mode that you have selected. We won't cover every special mode you may have on your camera, as they vary from model to model. Here are several of the most common options and what they do for your photography.

Manual

The shooting mode that started it all. You set the shutter speed and aperture, as you wish, accepting or ignoring the camera's recommendation for "correct" exposure. All other setting overrides remain available. Choose this mode if you're experimenting with manual exposure control but take care not to make images that are incorrectly exposed.

Aperture Priority

In this semi-automatic mode, you select the aperture, thereby determining your depth of field; the camera automatically sets the suitable shutter speed to match the conditions. If you change apertures (from f/5.6 to f/11 for example), the exposure remains the same, because the camera automatically changes the shutter speed.

This is a terrific mode to use with a stationary subject when you want to control your depth of field and aren't concerned about shutter speed. It's also a good choice when you want the camera to

automatically select the fastest possible shutter speed: just set the camera to its widest aperture. Many professionals choose Aperture Priority as their default setting when depth of field is the most important consideration.

Shutter Priority

This semi-automatic mode helps you control motion, both as it relates to the subject and the camera. You select the shutter speed and the camera sets the suitable aperture. If you change the shutter speed (from 1/60 to 1/250 second, for example), the exposure remains the same, because the camera automatically changes the aperture. All overrides are available, including exposure compensation, so you can achieve exactly the intended image brightness.

Use Shutter-Priority mode when you want to control the shutter speed. This can be crucial for a subject that is in motion.

You'll often want to use Shutter Priority mode for moving subjects, as in sports photography when you want to "freeze" the subject with a very fast shutter speed. Photographing a walking person might require a shutter speed of 1/125 second, and a golf swing might take 1/500 second. Conversely, there will be times when you want to select a slow shutter speed, such as for blurring moving water in a stream; try a speed between 1/15 and 1/30 second when experimenting.

Standard Program

This all-purpose, automatic exposure mode can be used for general photography. In this mode, the camera selects a median shutter speed and aperture based on the meter reading. Usually some fine-tuning of features like exposure compensation, flash output, and white balance is possible. Most cameras allow you to shift the aperture/shutter-speed combination; the exposure does not change if you take advantage of that feature.

Most of the standard Program modes try to give some blend of shutter speed and aperture setting that will allow for handholding and be fast enough to freeze action, yet still provide satisfactory depth of field. (In low light however, be sure to set a high ISO level for fast shutter speeds.) Naturally, not all manufacturers design their Program modes in the same way.

Learn how your own camera's Program mode responds in various lighting conditions. As you become more experienced, you'll be better at guessing the combination of shutter speed and aperture that will produce the results you want. You then can shift the aperture/shutter speed with some expertise to achieve the results that you want: a smaller aperture perhaps for greater depth of field, or an even faster shutter speed to "freeze" the motion of a moving subject.

Auto

Of all the modes available on digital cameras, this one probably requires no introduction. If you just want to point and shoot, or hand the camera off to someone else and need a foolproof setting, this is it. (Not all cameras include this Auto mode, however.) The camera will make all the decisions and lock out any overrides that might be set inadvertently by a novice: exposure compensation, white balance selection, and ISO are disabled by most cameras in Auto mode. Note that if you find you are unable to make these adjustments when photographing, check the camera to make sure it's not set to Auto.

Program mode or Auto mode are convenient for travel and street photography.

Use Portrait mode with a longer focal length lens setting. This produces shallow depth of field that accentuates the subject.

Portrait Program

Flattering portraits emphasize the subject by de-emphasizing the background. When you choose Portrait mode, the camera will select a wide aperture setting, minimizing your depth of field, and also may adjust your zoom to a longer setting. The combination should produce an image with a more blurred background.

In portrait photos, accurate focus is important because with less depth of field, your margin for error is reduced. Make sure that the eyes of your subject are in sharp focus.

More advanced cameras might even alter the in-camera processing of the image to accentuate skin tones and to moderate sharpening for a flattering effect. The flash will usually set red-eye reduction when shooting in Portrait mode. The camera will probably not allow you to select any overrides in this fully automatic mode.

If you're shooting a group of people, Portrait mode may not be the best choice if the subjects are standing at varying distances from the camera. In this type of situation, you'll need more depth of field to ensure that everyone is sharp. Choose Aperture Priority mode instead to select the smallest aperture possible (such as f/11 versus f/4). Because a small aperture will cause the camera to set a long shutter speed at low ISO settings, you may need to set ISO 400 to be sure of getting sharp pictures without blur from camera shake.

Landscape mode will set a small aperture to maximize depth of field. Check that your camera doesn't set a shutter speed to slow for handholding when you use this mode.

Landscape Program

In Landscape mode, your camera will select the smallest aperture possible under the conditions to maximize depth of field (the range of apparent sharpness) in the image. The camera will probably not allow you to select any overrides in this fully automatic mode; it may also disable the flash.

As with any subject-specific Program or Scene mode, some cameras will also apply effects such as sharpening and color saturation adjustment; in Landscape mode, the system might boost the richness of green tones, for example. While this mode will attempt to deliver sharpness from the foreground to the background, it isn't always possible because success depends on the light and the capabilities of your lens and camera. In low light, even Landscape mode will set wide apertures for fast shutter speeds to minimize the risk of blur from camera shake. For this reason, be sure to set focus on the most important subject element that needs to be sharp.

Sports mode sets a high shutter speed to freeze action.

Sports Program

Action photography demands a fast shutter speed to freeze the motion of your subject. Switch to Sports mode and your camera will automatically choose the fastest shutter speed possible so you can concentrate on the action. Naturally, in dark conditions—inside an arena, for example—the shutter speeds may not be very fast so your action images may be blurred.

The camera may not allow you to select any overrides in this fully automatic mode. Depending on the capabilities of your camera, Sports Program will activate continuous framing (as opposed to single frame) to help you capture the decisive moment in a series of shots. If your camera has an evaluative metering mode, this likely will be employed rather than center-weighted or spot metering. Flash is usually disabled because most action subjects are too far from the camera: beyond the "reach" of light from the flash.

Macro Program

The term macro refers to extremely close focusing on subjects that are only a few inches or less from the camera. Extreme close-ups usually make for interesting images, provided that they're sharp. Most digital cameras with a built-in zoom include either a Macro Program mode or a Macro focusing option. Both options force the camera to focus much closer than usual, sometimes just a few centimeters from the front of the lens.

Use the Macro mode when the little details really count: to fill the frame with small items of jewelry, for example. Depending on your camera, your zoom range may be restricted to wide angle settings; you also may be required to manually set focus. The camera will probably not allow you to select any overrides in this fully automatic mode; it may disable flash to prevent excessive brightness that can occur in extreme close-up photography.

To get the best results, a tripod is recommended to prevent blur from camera shake, a real problem in any high magnification photography. When the camera is mounted on a tripod, a flip-out, swiveling LCD monitor is a huge benefit, as you can adjust the angle of the LCD screen to give you a clear view of the image even in tight quarters.

Night Program

In cameras that include this option, Night Program simply sets a very long shutter speed to provide a good exposure of a typical low-light scene. The camera will probably not allow you to select any overrides in this fully automatic mode. Using a tripod is absolutely necessary for sharp pictures due to the long exposure times.

This raises quality issues of which you should be aware. Digital camera sensors are particularly susceptible to noise problems during long exposures. The sensor must remain active for the duration of the exposure, which generates heat. This heat, in turn, can cause pixel errors that show up as grain-like irregularities or colored specks in the image. Some of the more advanced cameras have technologies that help reduce this problem in long exposures, such as a Noise Reduction mode, either selected automatically or by the user. Even when that feature is enabled, image quality will suffer either due to some digital noise or an overall softness produced by the processing system. (Softness makes the noise pattern less obvious but that's not necessarily an ideal effect.)

So, if possible, try to include a lot of ambient light in your night photography, so the shutter speed will not be extremely long. Or, choose to compose your shot with objects in the foreground that can be illuminated by flash to add light to the exposure. Of course, that assumes that the camera will allow you to activate flash in Night Program mode.

Night mode will set a very long shutter speed. Use a tripod or find a stable surface to set the camera on during the exposure.

Night Portrait Program

Also called Night Scene mode by some manufacturers, this option is available in many cameras. When selected, the system sets a moderately long exposure (perhaps 1/2 second) to capture the low ambient light of the background light and a reduced-intensity, slow-sync flash with red-eye reduction to softly illuminate the subject in the foreground. This gives a pleasing balance between the flash and existing light. The camera will probably not allow you to select any overrides in this fully automatic mode. A tripod is important in this mode, as you want the ambient light to be as sharp as the subject illuminated by your flash.

For photographing people in dark scenes, Night Portrait mode will illuminate the foreground subjects with flash and set a long shutter speed to capture the ambient light.

Beach/Snow Program

The often bright, reflective, and contrasty environment at the beach or in snowy landscapes provides an exposure challenge for even the most sophisticated metering system. It's easy for the meter to be fooled into "thinking" that the scene is much brighter than it really is; that can cause the camera to underexpose the image. If your camera includes this Program mode, use it in ultra bright conditions; it will compensate for the abundant ambient and reflected light by slightly overexposing based on the meter reading. However, the camera will probably not allow you to select any overrides in this fully automatic mode.

Glare from sand and water can "fool" the camera's meter and produce a poor exposure. Beach/Snow mode will compensate for highly reflective scenes.

A or **Av** **Aperture Priority**—This is a terrific mode to use with a stationary subject when you want to control your depth of field and aren't concerned about shutter speed. In this mode, you select the aperture setting (f/stop) and the camera automatically sets the best shutter speed for correct exposure, depending on the lighting conditions.

S or **Tv** **Shutter Priority**—You'll usually choose this mode when you want to capture a moving subject: either as "frozen" in time or blurred for an effect of motion in a still image. In this mode, you select the shutter speed and the camera chooses the best aperture for a proper exposure.

P **Program**—This all-purpose automatic exposure mode can be used for general photography. In this mode, the camera selects a median shutter speed and aperture based on the meter reading. You can shift the exposure settings to select various aperture/shutter speed combinations.

 Portrait—The camera selects the widest possible aperture setting to minimize depth of field for a softened background. Remember to focus on your subject's eyes. Some cameras will also adjust the sharpness, contrast, and color rendition to selections that are suitable for a typical portrait. The flash usually will switch to the red-eye reduction setting.

 Landscape—In Landscape mode, your camera will select the smallest aperture to maximize depth of field. Your image will be as sharp as possible in both the foreground and background. Some cameras will also adjust the color rendition to one that's suitable for a landscape.

 Sports—Speed is the name of the game in Sports mode. Your camera will automatically choose the fastest shutter speed possible, and also will enable continuous high-speed shooting if available. Continuous autofocus may also be engaged if your camera includes this feature. Evaluative metering is usually the default for this mode.

 Macro—One of our favorite features of compact digital cameras is the ability to shoot extreme close-ups without a special lens. Macro mode allows you to focus on objects that are only inches (or perhaps only centimeters) from the camera, though your zoom range may be restricted.

 Night—Successful night photography requires a slow shutter speed for a long exposure without flash. The exposure may last several seconds, so use a tripod when shooting in this mode.

 Night Portrait—This mode uses a combination of flash with a long exposure to pick up ambient background light. The flash exposes your subject and freezes its motion amid the lengthened exposure. Whenever possible, use a tripod with this mode for best results.

 Beach/Snow—The bright reflections and high contrast of sand and snow can trick your camera's meter into underexposing the scene. This mode will slightly overexpose the image based on the meter reading.

The Marvelous LCD Monitor

The little screen on the back of your camera offers many benefits; follow these tips to get the most from it.

By Rob Sheppard

The LCD monitor is probably the biggest thing about digital cameras that has changed the way we photograph. The ability to immediately display the picture you just shot provides instant feedback on how well you're doing with your subject. You can see if the composition looks good. Was the exposure right? Did the subject blink? Did you include some distracting elements?

The ability to review images instantly has even made professional techniques more accessible to all photographers. For example, I used to do studio photography where we shot with strobes (flash systems). Although the flash had modeling lights, we could never be sure of our lighting effects unless we shot some test Polaroids to see exactly what we were getting. An actual image on an LCD monitor truly is better because you see the real photo almost instantly—not a substitute that has to be retaken with "real" film that takes a minute or two to develop. Now everyone can use flash and check the results to be sure they got the shot. And you can use this very real tool at any time and in any light.

The instant review feature available with digital cameras has truly been a revolution in picture-taking for many photographers. There's no longer any need for the "hope-I-got-it" attitude. Instead, one just checks and re-shoots if necessary, making changes in composition, exposure, or other technical aspects. Again and again, photographers find that they love being able to respond to both the subject and the photograph at the same time. It allows us to make changes while the subject is still there.

But sometimes the LCD panel isn't used as effectively as it could be. It can be difficult to see in certain light and requires a conscious effort to use it all the time (especially if you were shooting film before). But it's worth the effort. A representative of a prominent camera company once surprised me by telling me, "You don't need to check shots…a good photographer should trust his or her craft." I thought, evidently, a lot of pros (like me) aren't good photographers, since we do check shots. Why wouldn't we?

Using The LCD Monitor

Here are a series of tips to help you get the most from your LCD screen:

1. **Set the Review Time**—After you take the picture, a digital camera will typically display the photo briefly on the LCD monitor. I like this reassurance that I got the shot, but the feature can be turned off, a good idea if you're running out of battery power. The important thing is to set a display time you like. The preset default times (such as one second) are usually deliberately conservative to save battery power—usually too conservative for me. I like to set the review for at least eight seconds. The review image will disappear when you press the shutter release slightly.

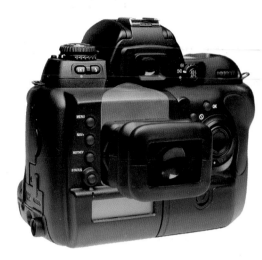

There are many hoods and shades available that keep light off the LCD, making it easier to see your image in the monitor.

2. **Learn to See It**—It takes a little practice to be able to see the image in an LCD monitor in all types of light. Newer cameras have brighter monitors, but you still have to spend time looking at the LCD screen in a variety of light conditions. With some practice, you'll be surprised how much more you can see and how often you'll use the monitor. Most cameras allow some adjustment of monitor brightness (this is usually found in the menus). But this can be tricky. Too much brightness makes the screen lose contrast, and details in highlights can be hard to see.

3. **Shield the Screen from Bright Light**—A hand, a hat or your body's shade can block light that would strike the monitor, making the image easier to see. For serious review of a series of shots, find a shady location. A hat can be a useful addition to your shooting kit because it works wonders for shading the monitor. Several manufacturers also make hoods that attach to the camera, blocking the sun to allow a better view of the tones and colors of a photo. Some photographers even take along a dark cloth (or use their jacket) to put over their heads to shade the screen on sunny days.

4. **Learn to Interpret It**—This is very important. The monitor on the LCD hasn't been calibrated to match your computer monitor, nor is it designed to show you everything important in the photograph. With experience, you'll be able to make mental adjustments to what you see in the monitor, as you'll learn how your camera's LCD screen deals with contrast and color. Use the magnifying button or dial on your camera to enlarge the image as needed so you can better examine details (such as sharpness and highlight detail).

5. **See It as a Photo**—When looking through a viewfinder, even the best photographers sometimes forget to "make a photograph" from the scene and just frame a subject. The LCD monitor now shows you a miniature version of your image, a nicely displayed photograph on the back of the camera. In some ways, the small size of this image can be helpful because it makes you look at how strong the composition, contrasts and colors are in the image. This is a great advantage of the "live" LCDs of compact digital cameras: they allow you to view an actual image on the screen rather than viewing the scene itself through a viewfinder.

6. **Watch the Edges and Other Details**—How often have you been surprised to see something creep into the edge of your photo? It happens to everyone. Maybe worse, a distracting street sign shows up right behind a tender portrait. When shooting film, you might not have been aware of this distraction until your prints came back from the processor. In the excitement of photographing some subjects, there's no question that we can miss distracting details. While shooting, check the LCD monitor to be sure you're not including extraneous elements—things you don't want in your photo. Fixing the problem on the spot by taking a new photograph is a lot easier and faster than trying to correct it later using Photoshop.

7. **Experiment**—I find that a digital camera absolutely encourages me to experiment, and I love doing it. I no longer have to worry about wasting film, and now I can see the results of my experiments immediately. That way, I can make technical or compositional adjustments to get the best photo possible. Or I can decide that the experiment isn't worth much and just delete it, or save it for later review on a computer monitor. But the best thing is that you still can make changes while you're with your subject, and that should allow you to make excellent shots.

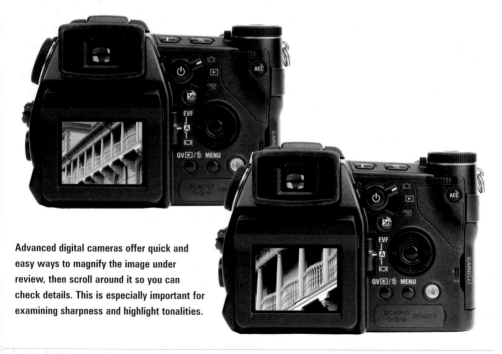

Advanced digital cameras offer quick and easy ways to magnify the image under review, then scroll around it so you can check details. This is especially important for examining sharpness and highlight tonalities.

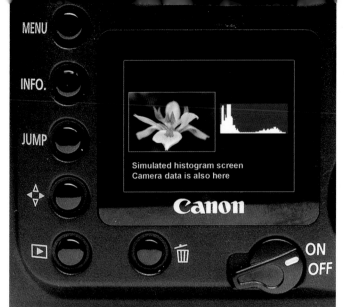

Many cameras offer the ability to see your image, plus a histogram. This is extremely valuable in helping to judge exposure. That screen usually will have a variety of camera data as well.

Simulated histogram screen
Camera data is also here

Check Your Exposure

Elsewhere in this book you'll find more detailed explanations of exposure and histograms, but let me emphasize one thing here: the camera's LCD monitor is a huge benefit for getting the right exposure. Studio pros long have used Polaroids to check exposure. They'd take a shot with a Polaroid back (a special film holder) on their studio camera and then process that film to check the image for exposure and contrasts.

Even then, photographers couldn't be absolutely sure because what was seen in the Polaroid still wasn't the final shot on film. They had to then take more test shots and, due to unavoidable variations, photographers would often do something called a clip test. They'd have the processing lab clip and process a portion of film (one frame); when reviewing that single shot, they could decide if any final adjustments needed to be made for processing the entire roll of film to produce final images with perfect exposure.

The LCD screen is so important, I'll say it again. It allows you to check the exposure on the actual image, and to continue checking it as the light changes! I strongly urge you to learn to read the histogram, as it provides a more effective check on exposure.

Even if you decide not to spend a lot of time learning how to interpret a histogram, the image on the LCD monitor will always give you a good idea of your exposure. While it isn't a perfect rendering of what your image can be, with practice, you can learn to accurately interpret what you see. Enlarge the image so you can see the highlights and see if important details are still there. Enlarge the shadows to see what's there. You might not be able to get an exposure that will capture detail in both areas (although flash might let you do so), but this way, you'll know for sure.

The LCD monitor is a basic, key part of a digital camera. Manufacturers now recognize how important they really are to the photographer, so they're making them larger and brighter, which is a benefit to all of us.

In-Camera Compression

Your digital camera has various means of storing more images onto a memory card.

By Christopher Robinson

Every digital camera that we know of uses the JPEG format as its primary option for image recording. Other formats may be available too, and we'll consider those briefly in this article; additional information on the RAW and TIFF options will be provided in subsequent chapters.

There's no doubt that the JPEG format is ideal for digital photography, because the image files are smaller than in other formats. If you've ever looked at a brochure from a digital camera manufacturer, you've seen some pretty remarkable figures about how many high-resolution images will fit on the memory card included with the camera. A 4-megapixel camera that comes with a 16MB card is touted as being able to store more than 100 high-resolution JPEG pictures. Even a cursory glance at the math suggests that the team whose job it is to come up with these numbers is probably the same team that's responsible for preparing the quarterly earnings statements.

Can a 16MB card hold hundreds of JPEGs? Maybe. But only if you're using the highest compression and lowest resolution camera settings. So why do manufacturers say you can store so many high-resolution pictures on that card? The marketers at most ad agencies all went to the Arthur Andersen/Enron/WorldCom school of higher math.

Control Image File Size

There are two factors that decide the overall size of a JPEG image file. First is the resolution you choose. That means how much of the image sensor's available pixels do you want to use as individual pixels. Although the terms vary from one camera to another, your options may include Large, Medium, and Small, denoting the resolution and the resulting file size.

Note: JPEG compression is lossy; some data is discarded when compressing an image file. The higher the compression ratio, the more data that is lost and the lower the resulting image quality will be. While the data is later reconstructed when you open the file in a computer, image quality will not be perfect.

The second factor is image quality based on compression. Your options may include Super Fine, Fine, Normal, etc. Depending on the Quality level that you select, the compression ratio will be extremely high, producing tiny JPEG files or moderate, for larger JPEG files.

Furthermore, these two factors can be combined. That is, you can shoot low resolution at low quality with high compression; that combination of options may be called Small/Super Fine. Or you might want high resolution at high quality or a high compression ratio; that combination might be called Large/Normal. Many cameras include additional options for image quality (extent of compression) and resolution or file size.

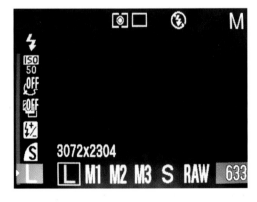

As the menu along the bottom of the screen shows, the camera offers a choice of five JPEG file sizes, plus RAW format file capture. The JPEG files are differentiated by image resolution with the largest size being 3072 x 2304 pixels.

There are also three settings for the amount of compression applied to a JPEG file. (The RAW files have no compression.) Use the lowest amount of compression as much as possible for the best results.

Compromising on File Size and Quality

Generally, I suggest that you always use your highest resolution (largest) setting. You paid good money for your high-resolution image sensor, so you should use it to its fullest potential.

If you must shoot smaller files because your memory cards are almost full, select a lower quality level for greater compression. I find that I can usually generate a better-looking print from a high resolution image that's been JPEG-compressed a little more than I can from a lower resolution image that's less compressed. Naturally, this assumes that I'm making a print that requires a substantial enlargement.

If I'm absolutely certain that I'll be making only small prints, I may choose a lower resolution and lower quality (less compression) combination. But you have to be very sure that your final print doesn't need to be large. If you're a little unsure, opt for high resolution and compress as needed for your memory card. Increased compression will reduce the image quality, but if it's your only choice, go ahead and take the picture.

Other Capture Modes

An increasing number of models allow you to shoot RAW files in addition to JPEGs. A RAW data file may or may not be compressed. In either case, it's larger than any JPEG file because cameras that compress RAW format files use lossless compression to maintain optimal image quality. That's a benefit over the "lossy" JPEG compression, but the difference between the two formats is not great if you used the camera's best Quality option for your JPEG files. Note too that a few high-end cameras also feature a TIFF capture mode that records huge files without any compression.

Low Resolution / Low Compression
Enlarged to 8x10"

High Resolution / High Compression
Enlarged to 8x10"

Both options may be useful at times, especially RAW capture, because of the image adjustment benefits discussed in other chapters. In our experience at *PCPhoto Magazine*, you don't gain very much in image quality by shooting in RAW or TIFF capture mode. We generally avoid TIFF capture entirely because the massive uncompressed files slow down a camera and fill up a memory card quickly. Most people will do much better to shoot JPEGs, using the largest file (highest resolution) and best quality (lowest compression) combination for excellent image quality and fast camera operation.

The camera was mounted on a tripod and two versions of this photo were made. One was a large (high resolution) image with high compression. The other was a small (low resolution) image with low compression.

selecting a
digital camera

Digital cameras are changing rapidly as technology develops and as the manufacturers determine exactly what consumers want and are willing to pay for. Higher resolution (measured in megapixels) is common in all price categories, from affordable to expensive, but a lot of new features are also becoming available. Even if you already own a digital camera, you should be aware of the recent developments and get a feel for what is available in the major price categories. The following series of articles offers a good overview of the state of the market and provides a buyer's guide for those considering a new camera with built-in lens or a digital SLR.

There are literally hundreds of digital cameras on the market and every week models are discontinued and new ones are introduced. That makes it impractical to provide any chart of all cameras, especially one that would be completely current. Although we will refer to some specific models as examples, be sure to check the manufacturers' websites for cameras that are actually available when you're ready to start shopping. Some large retailers' websites are also useful, providing full specifications—as well as the latest street prices—great for making quick comparisons.

Anatomy of a Digital Camera

The first step in choosing a digital camera is to identify all the various camera features.

By the Editors

Digital SLR

Photographers who have used 35mm film SLRs will mostly feel right at home with a digital SLR (D-SLR). The basic ergonomics, body design and control placement of most digital SLRs is quite similar to their film-based siblings. The buttons and dials used for attaching a lens, changing shutter speeds and apertures, checking depth of field, and setting focus and exposure metering on D-SLRs remain basically unchanged from familiar 35mm camera body designs.

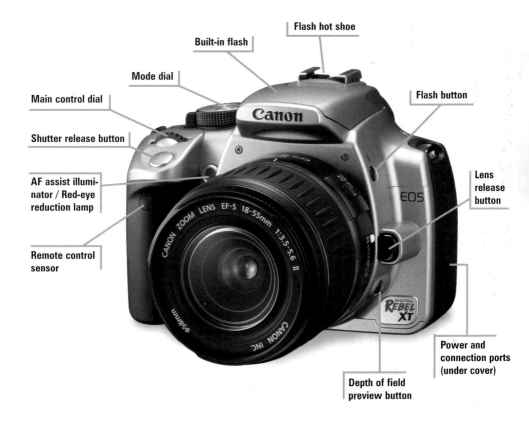

Flash hot shoe

Built-in flash

Mode dial

Main control dial

Shutter release button

AF assist illuminator / Red-eye reduction lamp

Remote control sensor

Flash button

Lens release button

Power and connection ports (under cover)

Depth of field preview button

Control placement varies among models and manufacturers, however, many of the icons used are similar or identical from camera to camera.

Camera manufacturers have made a deter-mined effort to simplify the transition from film to digital SLRs by making as many of the frequently used digital settings acces-sible without sifting through menus on the LCD monitor. And they've made improve-ments to the electronic menus as well. Today's typical D-SLR, while loaded with sophisticated technologies, is designed to be rather intuitive in use for the experi-enced film photographer.

Of course new digital features change some of the landscape; particularly on the back of the camera where the LCD moni-tor now takes considerable space. And with the digital features, new buttons and controls are added to provide quick access to them.

Diopter adjustment knob

Viewfinder

Aperture value /exposure compen-sation button

AE lock/FE lock /index/reduce button

AF point selector /enlarge button

Drive mode button

LCD illumination /direct print button

ISO/cross key up

Autofocus /cross key right

Set button

White balance /cross key down

Metering mode /cross key left

Card access indicator

LCD screen

• Menu button
• Info button
• Jump button
• Playback button
• Erase button

The Nikon Coolpix 5900 is typical of
compact cameras in terms of features
and control plaoomont.

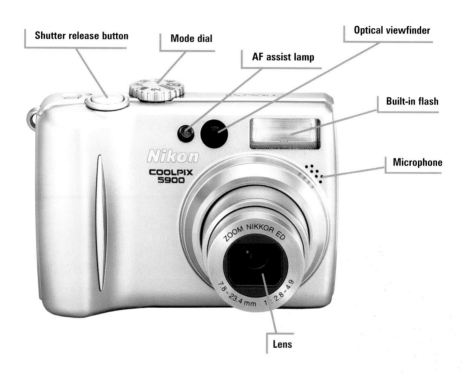

Shutter release button Mode dial

AF assist lamp

Optical viewfinder

Built-in flash

Microphone

Lens

Compact Digital Camera

If a compact digital is your first camera or even a replacement for a 35mm point and shoot, you may be overwhelmed at first with the myriad dials, buttons, and switches staring back at you from all sides. Fear not. It's possible you won't use many of those buttons on a regular basis anyway. Once you've found the power switch, mode dial, and shutter button, you're ready to start taking photos. The rest will come in time and practice.

For more experienced shooters, you'll find that compact digital cameras offer an amazing level of quality and control that you might not have expected. While easy to use for quick snapshots, these certainly aren't "point and shoot" cameras.

Switch the Mode dial from Auto to Manual and you'll have access to pro-level features such as exposure compensation and bracketing, manual focus,

exposure and focus lock, selectable auto-focus points and more. The high-end compacts are in many ways more comparable to a D-SLR than they are to the entry-level compacts that share their basic form.

Whether you're a new or experienced digital camera user, we recommend you take the extra minutes and read your owner's manual. These cameras often are so laden with features that it takes at least one full reading of the manual just to discover everything your camera is capable of doing.

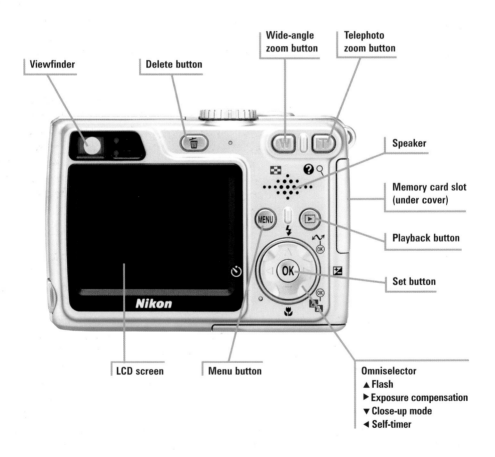

Wide-angle zoom button

Telephoto zoom button

Viewfinder

Delete button

Speaker

Memory card slot (under cover)

Playback button

Set button

LCD screen

Menu button

Omniselector
▲ Flash
▶ Exposure compensation
▼ Close-up mode
◀ Self-timer

State-of-the-Art Digital Camera Features

New technologies provide fast-working cameras and better photos.

By Zachary Singer

The underlying technology of digital cameras is evolving at a stunning rate, bringing benefits for all photographers from the casual snap shooter to the busy pro. Remarkable improvements in resolution and image clarity have brought cameras that can make much larger and sharper prints. Autofocus speed and accuracy continue to progress, and shutter lag, long the bane of digital shooters, is declining rapidly.

Along with advancements in familiar areas, new technologies promise better pictures as well. Image-stabilized cameras can help prevent blur in handheld images. Other developments include built-in software that can automatically post-process photos to reduce image noise, lighten shadow areas without lowering contrast, and eliminate red-eye.

Here's another example of brand new technology. Available in several Nikon Coolpix models, Face-Priority autofocus (available in Portrait Program mode) features face recognition technology, great for people pictures. When active, the system will focus on a face (the one closest to the camera) and maintain focus even if subject location changes. Although initial recognition takes about a second, the system is surprisingly effective and it clearly shows the focused area using a rectangle superimposed on the LCD monitor image.

All the sophisticated features wouldn't be much use to you if you couldn't compose your image properly, so larger LCD monitors and enhanced electronic viewfinders are big news. With all of these exciting improvements, you'll probably take more pictures, so you'll also be glad for the longer battery life available with many newer models.

Taken together, these developments add up to more fruitful photography now, while hinting of even better things to come. Here's a guide to today's digital cameras. Because technology is changing rapidly, even more new features are sure to with each successive generation of cameras.

High-Resolution Sensors

Advanced compact cameras boast resolutions previously unheard of, even in pro equipment just a few years ago. The ultra high-resolution image sensors supply enough pixels to make a nice 13 x 19-inch (33 x 48-cm) print, at least when using a low ISO setting. (High ISO images exhibit prominent digital noise that's obvious in large prints.) The sensors achieve this feat by packing seven or eight million pixels into the same space that the previous generation used for just five million, boosting the new cameras' resolution substantially over previous models.

Improved start-up times, less shutter lag, speedy autofocus systems, and higher frame rate for continuous shooting are all beneficial for capturing action.

Low-Dispersion Glass

There's more going on in the new high-megapixel cameras than the image sensors alone. A major, if less flashy, reason for better image quality is the increased use of low dispersion glass in the camera lenses. Formerly the province of high-end telephoto lenses for SLR cameras, low dispersion glass minimizes aberrations, especially those that cause color fringing.

Faster Start-Up

A digital SLR is ready to shoot as soon as you switch it on: in about 0.2 seconds. The cameras are generally ready to shoot almost instantly after they are turned on and exhibit no noticeable shutter lag. In other words, they make an image immediately after you press the shutter release button, except in low light where the AF system may take a half second to confirm focus.

Advanced compact cameras usually take a little longer to start up than D-SLRs, but they're gaining ground. Faster power up is common in the latest models especially those with built-in 3x or 4x zoom lenses.

Shutter Lag

Developing good timing on the shutter release is an important skill for photographers, but it's almost impossible with a slow-reacting camera. Shortened shutter lag is important so you'll be less likely to miss a fleeting photo opportunity. A shutter with minimal lag is also essential for techniques such as panning, in which the camera is moved at the same rate as the subject to keep the subject sharp while rendering the background as a motion-blurred streak.

D-SLRs are all quick, and some are lightning fast with no apparent delay after pressing the shutter release button. Some of the latest advanced compacts also boast an extremely short shutter lag. If you're considering a camera of this type, check the manufacturers' websites for specifics as to shutter lag for several models.

Faster Shot-To-Shot Times

Until recently we were generally happy with a compact camera that could take three or four shots in a series at a rate

of 1 frame per second (fps). Digital SLRs were already much faster of course, and could record a lot more shots in a single burst at about 2.5 fps. Both speed and burst depth have been improved on most cameras.

The 6-megapixel Nikon D70s for example, can shoot numerous full resolution JPEG images in a series at 3 frames per second; for the greatest burst depth, use a high-speed memory card. The more expensive professional or semi-professional D-SLRs are even more impressive in speed and burst depth.

Digital cameras with built-in lenses are also becoming faster, thanks to improved processing systems and larger buffers. A shooting rate of 2.5 or 3 frames per second, for at least four shots, is available with some high-end models.

In all cases, the ability to expose more images without waiting is due to several technologies coming together. Larger on-board buffers have allowed the cameras to hold more images in their electronic brains until they can be written out to the memory cards. Improved processing circuitry sends images through the system faster, easing the load on the buffers. And memory cards keep getting faster, particularly the SD and CompactFlash cards. Do note however that not all compact cameras can take full advantage of maximum card speed; the digital SLRs can, making ultra fast cards a definite benefit with cameras of that type.

Faster And Better Autofocus

Each new generation of digital SLR boasts a faster, more accurate autofocus system. Advanced microprocessors are the key to achieving autofocus that feels nearly instantaneous. Some of the latest compact digital cameras are impressive

too, in the speed and reliability of their autofocus systems. A few models even include predictive autofocus for follow-focusing on a moving subject. Such systems are not as fast or as effective for erratic motion as the predictive autofocus systems of D-SLR cameras, but they're useful nonetheless.

An increasing number of cameras of all types employ an autofocus sensor with multiple focus detection points, at least five. Most cameras allow you to select wide-area focus detection, useful for quick shooting with an off-center subject. Usually you can also select any single focus detection point for more precise focusing. Some cameras even allow you to position a focus detection point anywhere within the frame.

Numerous Overrides

It's amazing how many different user-selectable controls are available, particularly the mid-range and prosumer camera models. Even cameras that offer only fully automatic Scene (program) modes may include some overrides for ISO, White Balance, Sharpness, Contrast, Exposure, and Color Saturation. Most photographers consider ISO, White Balance, and Exposure controls essential. The other factors can be adjusted in a computer, using image editing software.

Still, if you often make prints directly from the camera or a memory card, you may want full in-camera control over sharpening, color saturation, and contrast. Be sure to experiment before setting each of these to a high level. Try the default settings first. You'll soon know whether you might prefer to get JPEGs with a bit higher sharpness or color saturation; lower contrast can also be useful, particularly in the harsh lighting of a very sunny day.

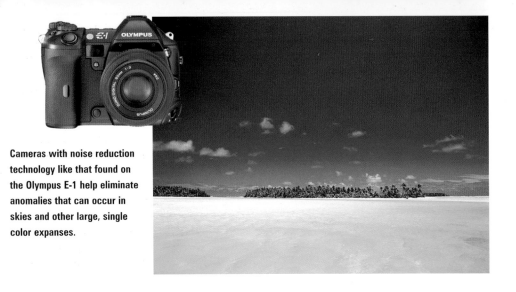

Cameras with noise reduction technology like that found on the Olympus E-1 help eliminate anomalies that can occur in skies and other large, single color expanses.

Wide-Angle Lenses

Advanced compact digital cameras generally included lenses with a focal length no shorter than a moderately wide 35mm equivalent. That's fine for some purposes, but many photographers prefer a wider angle of view. That's why some cameras now include a built-in zoom with a 28mm focal length equivalent. The trade-off is that the telephoto focal length is not as long as with other cameras, so you'll need to decide which aspect is more important in your own photography.

Until the advent of built-in zooms with a 28mm option, the only alternative for wide-angle-loving digital shooters was an add-on adapter; as discussed in the Accessories chapter, such accessories are available and compatible with some (though not all) advanced compact digital cameras.

In digital SLR systems, extremely short focal length zooms are becoming available, often starting at 10mm, 11mm, or 12mm, as discussed in the Lens chapter. Such lenses are very useful because most digital SLRs have a focal length magnification factor; that makes it impossible to

get a wide angle shot with a 28mm lens, for example, or an ultra wide angle shot with a 20mm lens.

Noise Reduction

Along with improving the imaging sensors for greater speed, camera makers are controlling image noise by processing the images more efficiently. For example, Olympus' TruePic Turbo (and the newer Turbo II) image processor reduces the random-pattern noise that appears in darker areas of an image or in images taken at higher ISO. Built into most newer Olympus cameras, these latest processors are also more effective in selectively controlling edge adjustment, better known as "sharpening."

Working like an experienced Photoshop user, the TruePic circuitry only sharpens sections displaying fine detail and avoids areas of even tones, like skies or skin. (Noise shows more readily in such uniform areas and would be accentuated if sharpened.) Because these even-toned areas don't have much image detail in

the first place, they can be "smoothed" instead, which diminishes the noise and improves the creamy appearance of that part of the picture.

Image Stabilization

Designed to produce sharper photos by compensating for camera shake, image stabilizer mechanisms are now built into advanced compacts cameras available from several manufacturers. This technology allows you to shoot handheld at slower shutter speeds without losing image quality due to motion blur caused by camera movement. (For D-SLR cameras, lenses with built-in stabilizer systems are also available.) Stabilizers work in two different ways. Some sense camera motion and

"counter-jiggle" some of the optical elements in the lens, neutralizing the effects of camera movement on the image. One system moves the entire CCD sensor unit (instead of the lens elements) to compensate for camera shake.

On average, the stabilizers allow you to shoot at shutter speeds that are two to three stops longer than with conventional cameras/lenses. Instead of shooting at 1/250 second with a 200mm equivalent lens, you can now shoot at speeds as slow as 1/60 or even 1/30 second if you're quite steady. With a 28mm equivalent lens, you should be able to get sharp photos at 1/8 second, instead of the more typical 1/30 second. Just remember, image stabilization cannot prevent image blur caused by subject movement.

Without image stabilization the shutter speed was too slow for handholding.

With image stabilization the same shutter speed produced a sharp image.

High-Resolution EVF

Electronic viewfinders (EVF) are common in digital cameras with a built-in zoom that's longer than 5x. An EVF is a tiny LCD screen that replaces the familiar optical viewfinder. Until recently, most EVF's were of low resolution, but this is starting to change. All manufacturers are improving their electronic viewfinders, but some are still much better than others; if shopping for a camera with an EVF, try several to determine which seems to be best in both bright and low light.

While no current EVF can quite match the clarity and immediacy of an SLRs ground glass, some electronic viewfinders offer an advantage over optical viewfinders. They can provide real-time information, like live histograms and the effect of your white balance setting that would be impossible for D-SLRs to show. Some EVFs also can provide a "boosted" image—with analog gain for a brighter view—allowing for easier composition in dim light. When you preview depth of field with an EVF, the lens stops down to the taking aperture, like a D-SLR lens, but the viewfinder image remains bright.

Larger LCD Monitors

An increasing number of digital cameras of most brands now feature large, easy-to-see rear LCD monitors of two inches or larger for a view almost the size of a medium-format camera's large ground glass. Even some ultra compact cameras boast a 2-inch or even 2.5-inch screen that's great for closely examining your images. Kodak has developed 3-inch LCD monitors while Casio has a 2.7-inch monitor currently available.

It should also be noted that many of the latest LCD monitors (of various sizes) are designed for easy viewing in bright light outdoors. That's useful when you're view-

ing a "live" image (before the exposure) for a perfect composition as well as afterwards, when reviewing the images that you have made. The "live" view before taking a shot is available only with cameras with a built-in lens. A D-SLR's monitor can only show the image after you have actually taken a shot. Even this is changing; the Fuji S3 Pro digital SLR is the first camera of its type to provide a preview image using video capture.

Durability And Weather Sealing

High-end professional D-SLR cameras make widespread use of magnesium castings for maximum strength with minimal weight. The bodies are also well sealed at all critical points to minimize penetration of dust and water. Some of the high-end pro lenses include rubber-like gaskets, making the entire camera and lens system sand- and water-resistant though not waterproof.

Not planning on buying a pro D-SLR any time soon? That's understandable considering the price and weight of such machines. Even so, you still may be able to take advantage of some of the advancements made in the pro arena as

A bigger **LCD** screen makes it much easier to view images, menus, and histograms.

Not just for rain and snow, weather sealing is a big asset when shooting in salty or sandy conditions, such as on a beach.

they show up in consumer-grade cameras. Every one of the 8-megapixel prosumer cameras with a built-in lens (available at the time of this writing) was built with a tough magnesium body, just like their bigger brothers.

"Dual-Pixel" Sensors

Fujifilm's SuperCCD SR sensor has two sets of pixels at each photosite for increased tonal range. The more sensitive detector of the two records shadow detail, while its less-sensitive counterpart records the highlights. The camera's circuitry combines data from each detector pair into finished pixels with increased dynamic range: detail at both ends of the tonal scale.

Optimized Scene Modes

When reviewing the Nikon D70 D-SLR we were impressed with the Digital Vari-Program modes, which took Scene modes to a new level. Like the Scene modes in other cameras, the D70 offers settings for sports, portraiture, and landscapes, as well as night versions of the last two. The key difference is that along with setting an appropriate f/stop and shutter speed for the type of subject, the D70 also changes the way the digital images are processed, optimizing them

according to the input scene mode and the ambient conditions.

The camera will select saturation, tone, hue, white balance and sharpening according to the type of scene you put in, as well as the quality of light the camera sees in your image. For example, a portrait image is processed with more flattering skin tones and texture in mind, so the camera uses lower color saturation and less sharpening than it would for sports or a landscape.

This type of technology is making an appearance in other brands of cameras as well, both compact and D-SLR. It's great and a definite advantage over the more typical subject-specific Programs that have been available for many years with all types of cameras.

Advanced In-Camera Processing

Innovative electronic circuitry provides automatic treatment of an image's problem areas, like the red-eye that results from on-camera flash. Several high-end compact cameras now include a feature that automatically opens up shadow areas, brightening them without affecting the overall image brightness or contrast. The system produces images that look more like the scene as you saw it.

Some cameras also provide preliminary alignment of individual frames to form a panoramic photo. Along with providing an outline of the previous frame on the LCD to help you align the next one, the camera stitches all the frames together for a preview of the finished image. All of these features, used together or independently, will reduce the amount of time users spend tweaking their photos in image-processing software.

RAW and RAW+JPEG Capture

The RAW capture mode is not essential, but it offers some advantages. The white balance and other settings can be changed after the fact with just a click of the mouse. This offers a quicker means of experimentation than taking individual JPEG images at every possible combination of white balance, saturation, contrast, and sharpening. Since RAW files allow readjustment of the original settings, mistakes can be fixed easily.

Many D-SLRs now can record your images in RAW and JPEG formats at the same time. This RAW+JPEG capability provides the image quality of RAW files and the convenience of JPEG, a format that's recognized by all imaging software. The combination gives you JPEGs for quick sorting in most browsers and easy sharing by email. The larger RAW files can be used for more serious purposes, such as making large prints.

Longer Battery Life

Due in part to improvements in battery technology like the move to lithium-ion cells, many cameras now can expose hundreds of images on a single charge of their batteries. Many new cameras that use large lithium ion batteries can shoot approximately 400 images on a charge, even when flash is used for one-quarter of the shots. (A camera's specifications usually include information on the number of shots you can get per charge.)

Using RAW files and processing software like Nikon Capture can dramatically improve your control over the image.

Just as importantly, though, the cameras' processing systems continue to gain in efficiency. In spite of its 8-megapixel resolution and increased firing rate, the Canon EOS-1D Mark II takes more than 1,200 exposures on a single charge. That's more than double the number of its 4-megapixel predecessor, and both cameras use the same battery.

Wireless Image Transfer

Several of the professional Canon and Nikon digital SLRs can use an optional high-speed wireless transmitter to send images to a computer network. Used by professionals at sporting events, the system also can interface with the growing number of hotspots for wireless networking around the U.S.

Wireless transfer is being developed for compact cameras as well. By adding a Wi-Fi card, the camera can transfer images to a computer with no connecting cord. It can also be used to send pictures and videos by email using a compatible home network or public hotspot.

If your camera has a wireless transmitter or accepts a Wi-Fi card, you can transfer, print, and share images without any connecting cables.

A Digital Camera Buyer's Checklist

Use this checklist to help you determine the digital camera that's right for you.

By Wes Pitts

After nearly seven years as an editor at *PCPhoto*, I recently purchased my first digital camera. I've been shooting with digital cameras all along, but since there's a constant flow of the latest and greatest equipment through our offices, I never felt compelled to commit myself to making a purchase. Content with just borrowing a camera for a time, I was reluctant to buy because I assumed that something better would always be on the horizon.

I finally made the plunge and purchased a digital camera. Why the change of mind? I fell in love with an 8-megapixel beauty. I won't tell you her name, as I don't want to make the others jealous, but this camera satisfied just about every item on my digital camera wish list.

We've compiled the key features that you'll want to consider before buying a new digital camera to make your shopping experience easier. Complete the quick survey at the end of this section and take it with you when you shop.

Resolution

Most photographers' needs can be met with files produced by current cameras. The 7- and 8-megapixel models produce files that make for very good large prints with stunning detail and sharpness. The high megapixel cameras are the way to go if you like to make big prints of your work. The 5-megapixel models deliver impeccable 5 x 7-inch (13x18-cm) and beautiful 8 x 10-inch (20 x 25 cm) prints, so if you don't expect to make prints larger than 8 x 10 inches, you should be happy with one of the better 5-megapixel cameras. They're less expensive and the lower-resolution images take up less space on your memory card; the smaller JPEGs can also be downloaded to your computer more quickly and consume less space on a hard drive or CD.

Lens

If you opt for a digital SLR camera, you can choose from a wide array of inter-changeable lenses. Unlike D-SLRs, compact digital cameras have a built-in lens. Most digital camera lenses have a zoom range of at least 3x. A common range is 35–105mm (35mm equivalent), versatile enough to handle everything from moderately wide scenics to tight portraits.

The typical 3x range is enough for most photographers, but if you want to work with longer focal lengths, you'll prefer a camera with a zoom range up to 150mm (35mm equivalent) or longer. Many compact models also allow you to augment the range of these lenses by attaching optional accessory lenses.

Size

Choosing a camera that's the right size for you is mostly up to your preference. If you're buying a camera primarily for vacation or spontaneous photography, a small camera that you can drop in your pocket is ideal. You might find that you take a lot more images if the camera is easily carried. The mini models have a shorter zoom range, however, as it's a technical challenge to fit much more than a 3x zoom in an ultra-small casing. Models with broad range zooms are larger because of the size of the lens.

Ultra-compact cameras also tend to be more automatic in operation, with fewer overrides and manual controls. A few models no longer include any type of viewfinder; you must compose using the LCD monitor.

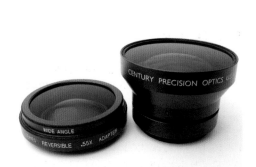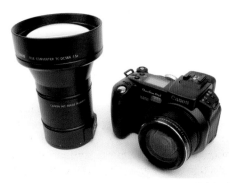

Using wide-angle and telephoto accessory lenses can expand your photography options. You may want to choose a digital camera that has an array of available accessory lenses.

If size isn't a concern, you'll have the most options in terms of features, lenses, and resolution when using a larger camera. The buttons and dials may also be larger, making them easier to use. For the ultimate in performance and control, you'll have to accept the camera's size for what it is, although even the bigger digital compact cameras are still small compared to a D-SLR with a zoom lens.

Are you looking for a camera with a variety of subject-specific exposure modes or would you like one that allows you to set exposure manually?

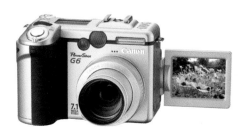

A repositionable LCD monitor is a desirable feature that you may want your camera to have.

LCD Monitor

The LCD screen is one of the most important parts of the camera, and not all LCDs are created equal. They vary widely in both size and positioning. Some are stationary and others swivel, rotate, and flip to give you a clear view even when the camera is pointed up, down, or sideways. Some are easy to view in bright sunlight, and others require you to be indoors or in the shade to view it clearly. You definitely should visit a retailer in order to compare the LCDs of the cameras you're considering. View them in the store and, if possible, outside as well, to see how easy they are to view in varying conditions.

The swiveling, rotating, and flipping LCD is a terrific feature that you'll get used to quickly. Even if your typical style of photography doesn't require acrobatics, you'll still find the ability to reposition the LCD monitor is a help. By changing the angle of the the LCD screen, you can reduce glare for better viewing.

Shooting Modes

Most digital cameras come with a variety of shooting modes, from old standbys, like Aperture Priority and Shutter Priority, to specialized Scene Programs that are fine-tuned for specific situations such as night exposure, landscapes, portraits, and more. If you like to shoot manually, the number of modes offered by the camera likely won't be important. Just be sure to choose a camera that has a true Manual mode, which lets you select both aperture and shutter speed to vary the exposure. (Some "manual" settings only allow you to select a few overrides rather than offer fully manual picture taking.) If you like the camera to evaluate your exposure for you, or if you plan on sharing the camera with less-experienced photographers in the family, then a model with several automatic modes would be a better choice.

Shutter Lag

As previously mentioned, shutter lag refers to the delay that occurs after pressing the shutter release button while the camera makes it settings. This is still an issue with many digital cameras with built-in lenses, particularly in low light when the autofocus system can be sluggish. While lag time can be reduced by presetting focus and exposure, it takes some getting used to.

Depending on the types of photography in which you normally engage, this delay may be just a minor hiccup, or it may be a more serious hindrance. If you typically like to shoot posed portraits, landscapes or still-life images, this isn't going to be a huge problem; on the other hand, those who shoot sports or candid people pictures may find it frustrating. Check the camera specifications for any data on shutter lag and be aware of any delay when you test cameras.

Memory Cards

Five different types of memory cards are currently used in digital cameras—CompactFlash (CF), SecureDigital (SD), SmartMedia (becoming rare now), xD, and Memory Stick. The type of media you'll use depends on the camera you choose. While a few cameras accept two types of cards, most accept only one.

The card formats differ primarily in size, but there are performance variances as well. CompactFlash (CF) cards have the highest capacities available and usually are less expensive on a per-megabyte basis. SecureData (SD) cards record slightly faster than CF, although newer CF cards are increasing in speed. If you own other electronic devices that use flash memory, you may want to get a camera that uses the same type of card, often SD. If you own two types of cards, you might want to consider a camera with dual memory card slots that allow you to use two different types of media (CF and SD or CF and xD).

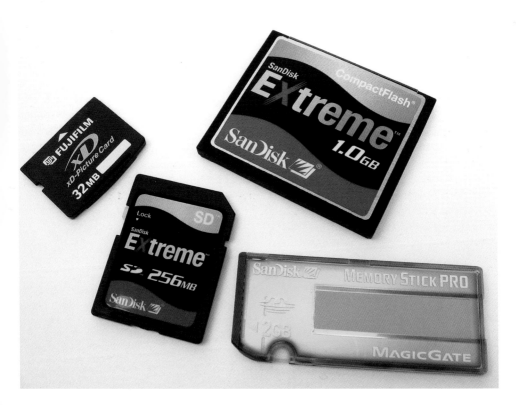

These are the four common types of memory cards: xD, SecureDigital (SD), CompactFlash (CF), and Memory Stick. The type of card you use is determined by the camera you select.

The Checklist

Using the following checklist to guide you while shopping
for a digital camera.

Resolution
I want:
- ☐ 6–8 megapixels (big prints)
- ☐ 4–5 megapixels (standard prints)

Lens
I want:
- ☐ A 3x zoom or a bit longer
- ☐ A telephoto zoom lens (up to 10x)
- ☐ A wide-angle zoom lens (starting at 28mm)
- ☐ Compatibility with wide-angle and telephoto adapters
- ☐ A digital SLR with interchangeable lenses

Size
I want:
- ☐ An ultra-compact camera
- ☐ A mid-size camera with better performance and more capabilities
- ☐ Size isn't a concern

LCD Monitor
I want:
- ☐ A large LCD (two inches or greater)
- ☐ A swiveling LCD
- ☐ LCD size isn't critical

Shooting Modes
I want:
- ☐ Full manual capability
- ☐ A mix of automatic and semi-automatic features plus overrides for exposure, white balance, ISO, color renditions, contrast, sharpness etc.
- ☐ Easy-to-use, automated Scene modes for specific subject types

Shutter Lag
I want:
- ☐ Minimal lag time
- ☐ Lag time isn't a primary concern

Memory Cards
I want:
- ☐ To use memory cards I already own
- ☐ A camera with dual card slots

The Olympus C-7000 gives you 7.1-megapixel resolution for clear, sharp, and enlargeable images. In spite of the camera's compact frame, it still packs a 38–190mm (35mm equivalent) zoom lens to give you a solid photographic punch.

Compact Cameras

Sleek and lightweight, these versatile cameras offer something for everyone.

By Zachary Singer

Digital compacts are for photographers who need an easy-to-carry camera that provides real photographic capability. The cameras in this league all have sufficient resolution to give you beautiful 11 x 14-inch (28 x 36-cm) prints from your very best low ISO shots, made with serious shooting techniques. Some of the cameras can produce images that enlarge nicely to 13 x 19 inches (33 x 48 cm).

Compact cameras generally include a straight-through optical finder while the models with long lenses employ an electronic viewfinder (EVF) instead. Although neither is as responsive as a D-SLR's ground-glass finder in most conditions, some EVF's offer a brighter view in low light. Like rear-mounted LCD monitors (and unlike D-SLRs), the EVFs also can show live images and information from the imaging sensor. That means you'll be able to see the effect of all your settings, including white balance and exposure, on the monitor before you take the shot.

Some cameras' LCD monitors can display a histogram after an image is made. Others provide a live histogram, which shows you the range of brightness in your image—*before* you take a shot—and helps you evaluate your exposures. By comparison, a D-SLR can provide a histogram only *after* an image is made.

In contrast to the LCD screens found in D-SLRs, you can flip up or twist out the LCD's of many of the advanced compacts. Those that flip up or down simplify shooting when the camera is used much above or below eye level, as when doing macro work or holding the camera overhead in a crowd. The monitors that twist let you do the same thing, but add the ability to do it when the camera is oriented for vertical compositions. You also can twist those monitors completely around to accurately compose images when you can't get behind the camera or when you're in the picture yourself.

You can purchase accessory add-on lenses for these advanced compacts and attach them over the front of the cameras' built-in optics. The accessory lenses (adapters) give you a range of focal lengths more like the large systems of D-SLR lenses. Telephoto adapters typically provide a 50% to 70% increase in the built-in optics' effective focal length, and the wide-angle adapters usually multiply the existing wide-angle's focal length by about 0.8x. That shortens the effective lens focal length considerably and widens the field of view.

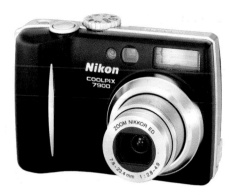

The Coolpix 7900 offers Nikon's exclusive in-camera red-eye fix, and boasts macro capability down to 1.5 inches (4cm).

Some of the cameras here have either a hot-shoe or some other means of synchronizing an off-camera flash. This is an advantage over simpler cameras because of the extra power and controllability that an external flash can provide. That extra power increases your flash-shooting range and offers stronger fill-flash when you're in bright light outside. A good external flash also can bounce light off ceilings or other surfaces for softer, more even lighting that gives your pictures a professional touch.

Choices abound between the cameras in this group. Some have lenses with smaller zoom ranges but faster maximum apertures (such as f/2.8), so you can shoot at faster shutter speeds, with lower ISO for

superior image quality, or in dimmer light. You could get a greater zoom range but slower maximum apertures (such as f/3.5–4) or choose wide-angle capability at the expense of a stronger telephoto.

Some of the advanced compacts in this range have a noticeably higher number of pixels on their image sensors, and some have optical or mechanical image stabilizer systems that compensate for camera shake inherent in handheld photography. Still other cameras can shoot RAW files for exceptionally flexible post-processing using the special converter software.

If these handy little machines have a drawback, it's that they're no match for a D-SLRs' ultra-quick shutter response. Most of the cameras in this category still have a noticeable lag between the shutter release and actual exposure; as a rule, the newest models are better in this respect than older models. A good chunk of the lag comes from the longer autofocus time, which can be reduced by pre-focusing before the instant of exposure; simply press the shutter button halfway to lock focus and hold it until you're ready to take a shot.

The Sony Cyber-shot DSC-W7 boasts a Carl Zeiss 38–114mm (35mm equivalent) Vario-Tessar zoom lens for sharp images.

The cameras shown are only a few of the models in this category.

Advanced Compact Cameras

Get resolution, optics, and features that rival digital SLRS, all in a compact design.

By Zachary Singer

The big brothers of the family, the advanced compact cameras are for serious photographers who want as much of a D-SLR's image quality and flexibility as possible, but in a smaller package with a built-in lens. These cameras give you more sophisticated equipment and capabilities than other advanced compacts at the cost of generally greater weight and expense. All of the cameras here have high-end image sensors that deliver exceptional resolution or an unusually wide dynamic range.

The Coolpix 8800 features Nikon's Vibration Reduction system, which shifts lens elements in the camera's 35–350mm (35mm equivalent) zoom to reduce image movement on the sensor, promising sharper handheld shots at long focal lengths or slower shutter speeds.

In this league, 8-megapixel image sensors are common; these can produce photos rivaling those from 6-megapixel D-SLRs in terms of the definition of intricate detail. Because of the smaller photosites on the smaller sensors, high ISO digital noise is worse however; a D-SLR is still preferable for high ISO image quality. Shooting with good photographic technique at the 8MP cameras' lowest ISO setting, you can make fine 13 x 19-inch (33 x 48-cm) prints.

These cameras are designed by their respective manufacturers for a more serious user than most of the other advanced compacts. It says a lot that every camera in this group offers RAW file capability, in addition to JPEG options, providing control over most aspects of an image, prior to conversion to TIFF format.

At this level, the majority of cameras have electronic viewfinders (EVF); in most cases, this type of finder is necessary because optical finders are not suitable for use with zooms that include long focal lengths; such lenses are common in this price range. On the whole, these EVFs provide higher resolution than most of those in the cameras' less expensive counterparts. The extra pixels in these viewfinders give you a clearer view for composing your shots. As in the other advanced compacts, the EVFs here can show you the effects of your white balance and other settings before you release the shutter.

The viewfinders of many of the cameras in this group also can display a live histogram, an ability that D-SLRs can't touch. As with all histograms, the live ones show you a graph of your image's brightness ranges so you can evaluate your exposure. The advantage of the live histogram is that you can see it while you're setting up your shot and make necessary exposure changes, instead of checking only after the picture is taken (and re-shooting as necessary).

The Konica Minolta DiMAGE Z20 offers Konica Minolta's Rapid Focus system for short shutter lag times at both wide-angle and telephoto focal lengths, and fast autofocus. Its Macro mode allows focusing as close as 0.4 inch (1 cm).

The cameras in this group give you a full system to work with. In addition to a broad-range zoom lens, all of the cameras accept adapters: accessory lenses to extend your wide-angle and telephoto range. In addition, every camera here accepts a shoe-mount external flash, and many accept macro lighting systems.

The camera makers have made a real effort to improve shutter release lag and startup times, and some of these models are among the fastest-acting advanced compacts on the market. Still, they remain noticeably slower than a D-SLRs nearly instant shutter response and start-up times. For subjects like fast action, a D-SLR may work better for you. The superior continuous tracking focus systems in a D-SLR is also a definite benefit with fast moving subjects.

In short, these cameras occupy a position between the smaller, somewhat less sophisticated advanced compacts, and the heavier, more expensive D-SLRs that accept many (optional) lenses. This group gives you a big part of the D-SLRs' image-making capability, trading the greater flexibility and speed of use of the bulky D-SLRs for a smaller, more transportable camera.

The cameras shown are only a few of the models in this category.

Fujifilm FinePix S20 Pro's Super CCD SR sensor delivers extended dynamic range by using two photosites for each finished image pixel—one captures the highlights and the other the shadows. The system also provides a fast minimum ISO of 160.

Digital SLRs

Professional performance and a large lens selection priced for every photographer's budget.

By Ibarionex R. Perello

For those of you in the market for a digital SLR, you have a lot of models from which to choose. Canon, Nikon, Sigma, Pentax, Konica Minolta, and Olympus all make consumer-grade models; the most affordable of these are available for under $1000, including a zoom lens. Most of the manufacturers also offer substantially more expensive D-SLRs, designed to meet the demands of working professionals who create thousands of images during the course of their assignments.

What to Look For

While there's no "best" camera, some digital SLRs are better suited for specific types of shooting than others. If you're interested in making big 16 x 20-inch (41 x 50-cm) enlargements, then you should choose an 8+ megapixel camera over a 4-megapixel camera. If you want

to capture fast action and the subtle variations of movement in high speed sports for example, you'll want the model that offers an ultra-fast continuous-firing rate with a long burst sequence. If you want to maximize the effects of ultra wide-angle lenses, you'll want a camera with a full-frame (35mm film size) sensor. Such cameras do not produce the lens magnification factor of cameras that employ a smaller sensor.

You'll find that there are unique features to every camera that may lead you to choose a specific model. The bottom line is that it's no longer a question of whether digital photography provides the quality that you need or whether it's even affordable. Now the question is which camera and system best allows you to explore your passion for photography.

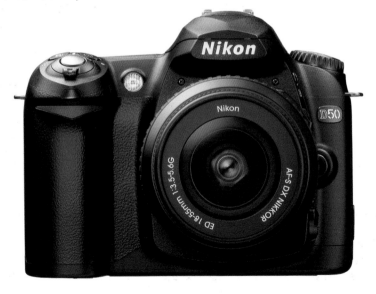

The Nikon D50 is a compact, lightweight digital SLR with a 23.7 x 15.6mm, 6-megapixel image sensor and a 2-inch LCD screen.

The Olympus E-300 is designed with the Four-Thirds chip size and includes a Supersonic Wave filter that automatically eliminates dust and debris from the image sensor.

Chip Size

When comparing the resolution of a digital SLR to some compact models, it can seem that an 8-megapixel point-and-shoot offers more for much less money. This is only partially true though. An equal pixel count doesn't necessarily mean that the image quality will be equal.

The CCD or CMOS image sensor in a digital SLR is considerably larger than the sensor used in a smaller camera. For example, the Canon EOS 20D digital SLR has an image sensor that's 22.5 x 15.0mm compared to the Canon PowerShot Pro1's sensor at 8.86 x 6.64mm, yet both sensors pack in 8 megapixels. The larger image sensor has bigger pixels and can capture greater amounts of light than a smaller sensor. This increased light gathering results in better color accuracy, wider dynamic range, and significantly less noise, especially at ISO settings of 400 and higher.

ISO Sensitivity and Noise

One of the benefits of shooting digital under rapidly changing lighting conditions is the ability to increase or decrease the camera's ISO sensitivity on the fly. Just as you'd experience more grain as your film ISO increased, you'll experience more noise at higher ISO settings. The multicolored speckles appear primarily in the midtones and shadows.

Most digital SLRs that cost no more than $2,000 provide excellent results with an ISO range of 50 to 400. Beyond that, you should expect some degree of noise with each full-stop increase, which can reach as high as 3,200. Still, don't be afraid to use a higher ISO setting if the situation demands it.

Startup and Shutter Lag

If you've used a compact digital camera, you likely know the frustration of slow camera startup. Turn on the camera and it can take several seconds before you're able to take a picture. Thankfully, today's D-SLRs have markedly reduced the startup time. They are ready to shoot almost as soon as they're turned on.

Shutter lag, the delay between depressing the shutter release button and the actual

moment of exposure, often can be just as aggravating. You'll notice a significant difference in performance in the digital SLR as opposed to most compact cameras.

Continuous Shooting

A convenient characteristics you'll enjoy with a D-SLR is its ability to take numerous images in rapid succession. For example, the Canon EOS 20D can expose five frames per second for a total burst of 23 frames. While the more affordable cameras can't match the pro units, they still can get you many shots in an instant. Such performance is largely dependent on the size of the camera's buffer and the speed at which it downloads data from the buffer to the memory card.

Exposure Modes

A function you'll often find in the consumer-model D-SLRs that you won't likely find in a pro D-SLR are special exposure modes. These settings are designed for specific photographic situations, including portraits, landscapes, close-ups, and more. The modes do more than just set the appropriate shutter speed and aperture; they also will bias metering, exposure, contrast, and color. This is an efficient feature for those times when you want to focus on creating the picture rather than handling the camera.

Lens Compatibility

If you already own a selection of autofocus lenses that utilize a Canon, Nikon, or Pentax mount, you'll be pleased to know that it's likely you'll be able to use many of those lenses on a digital SLR of the same brand. Because the image sensors are smaller than a 35mm frame, however, many lenses will perform as longer focal lengths when compared to a 35mm film SLR. The lens magnification factor is typically 1.5x to 1.7x for digital SLRs costing less than $2,000.

A 100mm lens mounted on a digital SLR with a 1.5x magnification factor will perform as a 150mm lens, for example. This is wonderful for photographers who prefer longer focal lengths because a 300mm lens on a film camera can be used as a 450mm lens on a digital SLR.

There are digital SLRs with an image sensor that matches the size of a 35mm frame of film, resulting in no magnification factor. These cameras come at a significantly higher price point.

The 16-megapixel Canon EOS-1DS Mark II features a full-frame sensor, meaning there is no focal length magnification factor to calculate. The camera utilizes the true focal length of the lens.

Why Go Pro

What differentiates a pro camera from less expensive models is more rugged construction, better seals against moisture and dust, a faster continuous firing rate, advanced metering and autofocus technology, and a wealth of user-adjustable custom functions. Much higher resolution is also available in a few of the pro D-SLRs as discussed later.

These cameras are designed for photographers who push their gear to the limit. They encounter extremely challenging shooting situations that involve harsh weather, lighting and a limited window of opportunity. When your paycheck is based on your photographs, your camera has to be rugged and reliable.

The camera must be adaptable as well. Professional photographers face varied shooting situations and need a camera that consistently delivers. Whether the camera is mounted on a basketball backboard or in the hands of a photographer who's yards away from a raging brushfire, it needs to handle practically anything thrown at it.

The cameras shown are only a few of the models in this category.

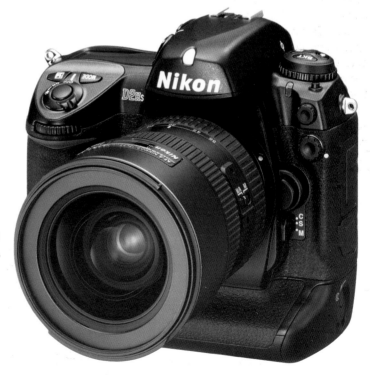

The ultra high-speed 4-megapixel Nikon D2Hs can shoot 50 JPEG or 40 RAW shots at 8 fps and includes new technology such as 3D-Color Matrix II metering and GPS support. When used with an optional Wireless Transmitter, the camera can transfer images to a laptop or server.

selecting and using lenses

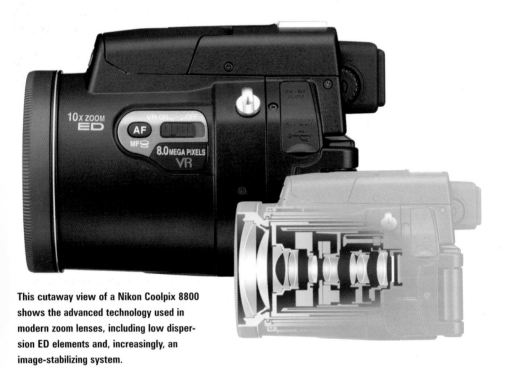

This cutaway view of a Nikon Coolpix 8800 shows the advanced technology used in modern zoom lenses, including low dispersion ED elements and, increasingly, an image-stabilizing system.

No matter how expensive or technically advanced a camera may be, it is still, primarily, just a light-tight box designed to hold the digital imaging sensor. It is the combination of the lens and the photographer's creative vision that makes the image. Consequently, the optics are an essential part of any compact digital camera or D-SLR system. Composed of an optical formula containing multiple elements, lenses focus light rays on a common point: the CCD or CMOS sensor. Other essential factors include: control of the amount of light striking the imaging sensor (depending on aperture size selected), the range of apparent sharpness within a scene (depth of field), the exact point in sharpest focus, the subject magnification, the amount of the scene to be included in the image, and the apparent perspective.

The following series of articles covers topics that will enhance your appreciation of all types of lenses, as well as specifics about using them with digital and 35mm film cameras.

Lens Buying Guide

Everything you need to know about focal lengths, maximum apertures, new technologies, and more.

By Zachary Singer

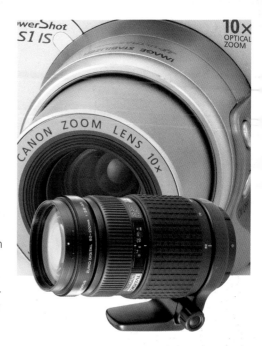

A trip to the camera store these days will show you an astonishingly vast array of lenses, from tiny zooms on compact digital cameras to big telephotos for digital SLR's. Many of these lenses are based on designs that were unheard of just a few years ago. They offer you new opportunities to expand your photographic capabilities—knowing what the lenses can do for you will help you make a better decision in your camera and lens purchasing, whether that means checking the zoom range of an advanced compact, buying a new lens for a digital SLR, or comparing lens speed among any group of lenses.

Lens choices for digital range from those built into advanced compacts to those designed specifically for D-SLRs and those designed for 35mm film cameras.

Lens focal length (such as 50mm or 200mm) is a key element. It affects angle of view, or magnification, perspective, and the physical size of the lens itself.

Angle Of View And Magnification

For any camera, the longer the focal length of your lens, the narrower its angle of view becomes and the more it magnifies distant objects and seems to bring them closer. Short focal lengths do just the opposite, giving you a wider angle of view while making objects seem farther away and smaller within the image.

Choose a focal length by what you want to accomplish. If you find yourself trying to capture a large part of your subject, but can't back up enough to include everything, a wide-angle lens may solve the problem for you. Wide-angles are great for photographing indoors or in any tight situations, or whenever you want to include a great portion of a subject as in landscape photography.

If you're always pursuing the smaller details of your subject and you can't come close enough to isolate them, then a telephoto is your answer. Telephotos are ideal for sports photography, wildlife, and for making the sun's image larger at sunrise and sunset.

Magnification Factors

As much as angle of view is controlled by lens focal length, it's also governed by the size of your image sensor. Some cameras use small sensors while others use much larger sensors. If you use the same focal length on two sensors of different size, then the angle of view, or magnification, will differ.

On a 35mm film camera, a 50mm is a normal lens. When a lens of that focal length is used on an 8-megapixel advanced compact digital camera, it gives an angle of view equivalent to 200mm on the 35mm camera. That's because the advanced compact's image sensor is four times smaller than 35mm film. Hence, its angle of view at any focal length is four times narrower and its apparent magnification is therefore four times greater.

The sensors of most digital SLRs are also smaller than a 35mm film frame but much larger than the sensors used in compact digital cameras. The apparent focal length magnification for most D-SLRs is 1.5x or 1.6x, but some models produce a factor of 1.3x or 1.7x or 2x when compared to 35mm film photography.

Mount a 20mm lens on a D-SLR with a 1.5x magnification factor, and it will cover that angle of view that a 30mm lens would on a 35mm SLR camera. Your 50mm lens behaves like a 75mm, and a 200mm lens acts like a 300mm in terms of angle of view and apparent magnification. This focal length magnification factor is actually field of view crop: the smaller sensor records less of a scene through any lens. Regardless of the

terminology, it's good news for those who love telephoto photography. The factor increases the effective reach of your existing telephotos without the light-loss penalty of a teleconverter.

Until recently, though, focal length magnification factors were a problem on the wide-angle side. When you mount your 28mm lens on a D-SLR, it's no longer a wide-angle lens. And an ultra wide 20mm lens from a 35mm SLR system does not produce an ultra wide-angle of view. This problem has been solved with entirely new lenses, discussed in more detail in a subsequent section.

Perspective

You can use distance together with focal length to expand or compress your picture's perspective at will. Move back and use a long lens for compression: objects at varying distances will appear closer together than the eye perceives. Move in close and use a wide-angle lens for a sense of depth.

This works because distance controls perspective—the closer you are to something, the more perspective foreshortening there will be. Foreground objects

These five images were taken from the same position to show the effect of focal lengths from 28mm to 200mm.

28mm view 35mm view

appear to loom large while background objects recede into the distance. When shooting up close, then, the wide-angle lens' job is to encompass the enlarged foreground objects so you can capture the resulting impression of depth. On the other hand, if you back up and use a telephoto lens, the same foreground objects will appear similar in size to the background objects, compressing the scene's perspective.

Sometimes subtle tweaks can be important. Portrait photographers, for example, use medium-telephoto lenses—from about 75mm to 105mm—to shoot head-and-shoulders images because a shorter lens—like a 50mm—can distort a person's face when you come close enough to fill the frame. With most digital SLR cameras however, you can use a shorter lens to achieve the same effect, as discussed in the next section.

Zoom Lenses

As with everything else in life, there are trade-offs to make when selecting lenses. Zoom lenses are great because they offer faster access to a variety of focal lengths than fixed-focal-length lenses, and they can be set at in-between lengths like 33mm or 165mm. In some cases, a single zoom can replace a bag full of lenses. Then again, most zooms aren't as "fast" as their single-focal-length counterparts: their maximum apertures are smaller—f/4 or f/5.6 versus f/2 for example—so the shutter speeds required to make an image are not as fast. That can be problematic in low light unless you're using a tripod. Granted, you can switch to a higher ISO setting (such as ISO 800) for faster shutter speeds, but image quality will suffer to some extent.

You'll notice that most zooms have a variable maximum aperture: wider at short focal lengths and smaller at long focal lengths. For example, a 28–105mm f/3.5–4.5 zoom has a maximum aperture of f/3.5 at the 28mm setting and f/4.5 at the 105mm end. With telephoto zooms especially, you'll notice the lens speed is reduced right where you need it most—at the long end. A relatively small maximum aperture of f/5.6 or f/6.3 is common at long focal lengths. Unless you use a high ISO setting, that means longer shutter speeds and a greater risk of blur from camera or subject movement. Of course, the smaller/variable apertures offer advantages that may be important to you: smaller size, lower weight, and greater affordability.

50mm view

100mm view

200mm view

Lenses for D-SLRs

As previously outlined, the vast majority of digital SLR cameras employ a sensor that's smaller than a 35mm film frame. While the cameras accept conventional lenses, there is an apparent focal length magnification factor, usually around 1.5x. Hence, a 50mm lens produces the angle of view that we expect from a 75mm lens in 35mm photography. And a 20mm lens is equivalent to a 30mm lens in terms of the area covered. That's why we need to use extremely short focal lengths for true wide-angle effects in digital photography. Most lens manufacturers now make short focal length lenses, especially "multi-platform" zooms, suitable for use with 35mm film cameras and digital SLR's. Many of these zooms start at a 15mm or similar focal length, providing a super wide angle in film photography and ultra wide in digital capture.

More recently, a special class of lenses was introduced, designed exclusively for D-SLR cameras with the small sensors. These "digital-only" lenses can be much smaller than multi-platform lenses because they only need to cover the sensors' smaller image area. This allows designers to create compact lenses with ultra-short focal lengths to compensate for the D-SLRs' magnification factor. Some of these lenses have focal lengths as short as 10mm, providing the equivalent of a 15mm, 16mm, 17mm, or 20mm lens on a 35mm camera, depending on the digital SLR's exact sensor size. One of these would be ideal for anyone who loves ultra wide-angle photography.

If these "digital-only" lenses have a downside, it's that they are not suitable for use with 35mm SLRs, or with D-SLRs using full-frame or nearly full-frame sensors. If you were to use them with such cameras, severe vignetting would occur at most focal lengths: the edges of the frame would be dark.

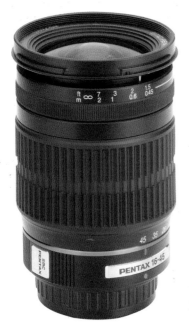

Pentax smc P-DA J 16-45mm f/4.0 ED/AL

Maximum Apertures

A casual glance through any manufacturer's SLR lens catalog shows a wide range of available maximum apertures. Many lenses open up to f/2.8 (or even wider), such as the 70–200mm f/2.8 zooms or some f/2 pro lenses. Such lenses are called "fast" because they allow you to use faster shutter speeds than lenses with smaller maximum apertures. You'll often have a choice between fast and slow versions of a lens (especially in zooms). Just choose one according to your needs and budget. Fast (wide aperture) lenses are bigger, heavier and more expensive, but they let you shoot in dimmer light with a faster shutter speed or with a lower ISO setting. The main difference between an expensive f/2.8 zoom and its less expensive f/3.5-4.5 counterpart is that the second lens has variable (smaller) maximum apertures while the f/2.8 lens maintains a wide aperture at any focal length.

That smaller, less expensive "slow" lens may be f/4.5 or even f/5.6 at the longer zoom settings, which is a considerably smaller f/stop. That can mean a difference of two whole stops in low light. The slower shutter speed required may mean the difference between a sharp photo and one blurred by camera shake. If you're not working at the limits of available light, though, the slower lens could do as well for you and it will be more compact, too.

If you check the built-in lenses of compact digital cameras, you'll find that the same concept applies to them as well. Some are fast, such as f/2.8 at all focal lengths. Most are slow, with variable maximum apertures such as f/3.5 at wide angle and f/4.5 or f/5.6 at telephoto settings. Again, the extra "speed" of a faster lens may not be important to you, but it's worth checking; if you often shoot in low light, you may want to pay extra for the camera with a wide f/2.8 aperture (or a moderately wide f/2.8–4) zoom lens.

When you're deciding on a lens for an SLR camera, keep in mind you'll find it easier to compose your pictures (especially in low light) with the brighter viewfinder image produced by wider maximum apertures. As well, your D-SLR's autofocus system will perform better with a fast lens such as an f/2.8 model.

Although AF systems commonly operate with lenses as slow as f/5.6 or even f/6.3, they're neither as discriminating nor as quick with such "slow" lenses as they are with fast lenses. If you like to focus manually, you'll find that easier with faster optics, too, because of the brighter viewfinder image produced by the wide maximum aperture.

Accessory Lenses (Adapters)

D-SLRs accept bayonet-mount interchangeable lenses, each of which has its own complete optical system. Along with all the glass, these optics have built-in focusing mechanisms, as well as an internal lens diaphragm to control your f/stop settings. Numerous lenses are available, in a variety of brands, for exceptional versatility.

Owners of advanced compact digital cameras with built-in lenses can extend their focal-length range significantly with accessory, or add-on, lenses. These optics attach to the front of your existing lens, reducing or lengthening the built-in zoom's focal length. Wide-angle adapters

There are wide-angle and telephoto accessory lenses, which can be added to the built-in lens on a compact zoom camera. With this 0.7x wide-angle accessory lens, the camera's 35mm lens becomes a much wider 24.5mm lens (both stated as 35mm equivalents).

shorten your focal length by about 20% to 30%. Telephoto adapters can provide anywhere from a 50% to a 300% focal-length increase, depending on the adapter's make and model; a 50% to 70% increase is common.

Because these accessory lenses use the cameras' focusing system, diaphragm, and electronic components, size and expense are kept to a minimum while still providing strong image quality. Some of the latest accessory lenses make use of the latest lens-making technologies.

Stabilization Systems

A photographic rule of thumb says that the slowest shutter speed to use when you shoot handheld is the one nearest the reciprocal of the focal length you're using; with a 50mm lens, you'd shoot at 1/60 sec., with a 135mm lens, you'd shoot at 1/125 sec., and so on. This applies to 35mm photography. With digital SLR's, you need to use even faster shutter speed because of the focal length magnification factor discussed earlier. Regardless of the camera, image-stabilizing systems give you sharp images at shutter speeds slower than you could otherwise use, typically two to three steps slower.

Most stabilizers work by shifting some of the lens elements to compensate for camera movement, thereby keeping the image motionless on the image sensor. Canon's Image Stabilizer (IS), Nikon's Vibration Reduction (VR) and Sigma's Optical Stabilizer (OS) are all examples of this technology. Konica Minolta does not make lenses with a stabilizer because they are unnecessary with the Maxxum D cameras. That's because an Anti-Shake system in the camera body shifts the image sensor to provide effective stabilization with virtually any Maxxum mount lens.

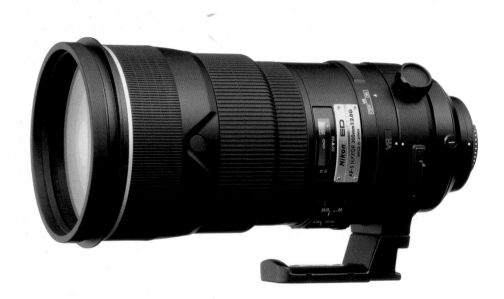

Nikon 300mm f/2.8G ED-IF AF-S VR Nikkor lens
The VR in the name of the lens stands for Vibration Reduction, Nikon's term for its image stabilization technology.

Interchangeable and Accessory Lenses for Digital Cameras

For best performance, high-tech cameras require high-tech glass.

By William Sawalich

The digital revolution has changed almost everything about photography. Sure, the cameras get all the attention, but the lenses have gone high-tech, too. Digital cameras have their own particular requirements—both compact zoom models and pro SLRs—and the lenses have evolved to keep pace. In the previous article, we have briefly discussed some important concepts; now, let's take a closer look at those issues.

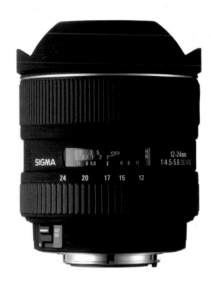

The Sigma 12–24mm f/4.5–5.6 EX DG Aspherical HSM lens can be used with D-SLR as well as film SLR cameras.

Digital SLRs

All but a handful of pro digital SLRs employ a CCD or CMOS sensor that is much smaller than the standard 35mm film frame. The smaller size of the imaging area is what causes the focal length magnification factor.

Mount a 35mm system lens on your D-SLR camera and the lens will project an image circle to cover a 35mm frame of film, but the small sensor will capture only a portion of the projected image. The resulting effect is a bit like cropping your pictures to include only the central part of the frame. As a result, the images appear as if they were made with a longer lens. In truth, the focal length is not actually magnified, but this is the apparent effect. This factor makes choosing the right lenses even more important.

It's important to know your own D-SLR camera's magnification factor: 1.3x is rare, but 1.5x and 1.6x are common. Two brands of cameras produce a different factor: 1.7x (Sigma D-SLRs only) and 2x (Olympus D-SLRs only). The higher the magnification factor, the shorter the lens you'll need for wide-angle effects. On the other hand, a high magnification factor means that telephoto lenses will provide much greater effective "reach."

Once you know the factor for your camera, determining the effective focal length is a simple calculation—multiply the lens' focal length by the magnification factor. A 1.5x factor will make a 50mm lens behave like a 75mm lens. Many digital SLR owners take advantage of this magnification factor by carrying smaller lenses that are just as powerful as the longer zooms or telephoto lenses used by 35mm camera owners. A 400mm lens on a D-SLR, for example, provides the equivalent of a 600mm or even longer in terms of the apparent magnification of a distant subject. Naturally, the 400mm lens is substantially smaller, lighter and more affordable than the 600mm model.

Digital Optimization Technology

There are other significant differences between film and digital imagers and these have sent lens designers back to the drawing board. The first difference is that the surfaces reflect light differently. Film is not very shiny; because of the anti-halation backing, glare and flare are minimized. A CCD or CMOS sensor is much shinier and that can create problems when using old lenses.

The mirror-like surface of a CCD or CMOS sensor means a greater risk of internal flare as light bounces from the sensor to the rear optical element. That glare can reduce saturation and contrast, as well as eliminating some image detail. As a result, lens manufacturers have developed improved glass coatings—applied to more of the optical surfaces—to help minimize the problems caused by internal flare.

For reasons that are beyond most photographers (unless they also happen to be electrical engineers), imaging sensors require light to strike the entire surface at an almost perfect right angle. If this condition is not met, the corners of an image may be darker and not as sharp as you would expect. By comparison, film is better at handling more acute angles of light striking its surface.

Engineers designing new lenses have addressed this issue as well. The new digitally-optimized, multi-platform lenses, as well as the digital-specific lenses, include technology for more even edge-to-edge brightness and sharpness in digital capture. Often, this includes some method that better collimates the light in order to help it strike the sensor at an ideal trajectory. (Think of it like a basketball—it's more likely to make it through the hoop if it's falling from above the rim rather than flying straight at it.)

D-SLR Lens Compatibility

Not all brands of digital SLR cameras are identical in terms of the types of lenses they accept. In the Canon EOS line for example, all D-SLRs are compatible with the familiar multi-platform EF mount lenses. Some newer digital EOS models, including the Digital Rebel, 20D and Digital Rebel XT also accept the new digital-specific lenses designated as EF-S, including the EF-S 18–55mm f/3.5-5.6 zoom available in some camera kits. These are more compact than EF lenses and are available in shorter focal lengths; designed specifically to match the smaller image sensor, an EF-S lens cannot be used with 35mm EOS cameras or the Canon D-SLRs with larger sensors. The new EF-S mount is also not compatible with earlier model cameras with small sensors, such as the EOS 10D.

Nikon's D-SLRs all use the same size sensor, so they all accept multi-platform AF lenses as well as the new DX-lens series designed specifically for digital cameras. Like any lens made exclusively for a D-SLR with small sensor, a DX lens should not be used on a 35mm camera or a D-SLR with a large sensor, such as the Kodak Pro series. While it may fit on the camera, the smaller lens will cause vignetting: severe darkening of the edges of the image.

Nikon DX lenses are more compact and lighter than typical Nikon AF models, but they deliver improved results tailored for the digital format. Nikon continues to develop this line and the number of DX lenses available is sure to increase. The most affordable model, the AF-S DX 18–70mm f/3.5–4.5 zoom, is even included in some Nikon D-SLR camera kits. Note too that all DX lenses are compatible with Fuji's S2Pro and S3Pro D-SLRs as well because those cameras also employ the small sensor size.

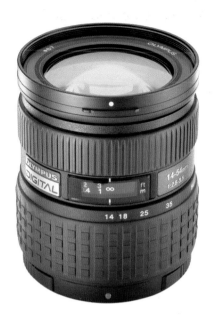

Konica Minolta was the last major manufacturer to make a high-resolution digital SLR cameras, the Maxxum D series, starting with the Maxxum 7D. Initially, the company offered only conventional (multi-platform) AF lenses but recently, new Maxxum zooms were introduced; these are smaller and designed exclusively for digital capture. Initially, two such models were available, the 17–35mm f/2.8–4 (D) and the 28–75mm f/2.8 (D), both fully optimized for use with Maxxum D cameras.

Sigma makes numerous multi-platform AF lenses, including the DG series (digitally optimized but suitable for all types of cameras) and the new DC series. The latter is intended exclusively for D-SLRs with a small sensor. Most of the DC lenses, such as the 10–20mm f/4–5.6 model, are wide angle or ultra-wide and quite compact. Available mounts vary, but all DC lenses are available for Sigma, Canon, and Nikon D-SLR's, while some are also available for Pentax, Konica Minolta, and Olympus digital SLRs.

Tamron also markets conventional AF lenses, Di-series multi-platform lenses optimized for digital capture, and a new line of Di-II lenses exclusively for D-SLRs with a small sensor. The new Di-II lenses, such as the 18–200mm f/3.5–6.3 zoom, are available in most popular D-SLR mounts and are quite compact.

The Olympus E-series SLR cameras incorporate an even smaller sensor called the Four-Thirds size. Consequently, these cameras are compatible only with lenses designed for this format (with 2x focal length magnification factor). You can find a growing number of Zuiko Digital lenses and a few Sigma lenses in the Four-Thirds mount; other brands may be available in the future. Since the CCD is so compact, the corresponding lenses and their effective focal lengths come in smaller, lighter, and faster packages. That's part of the reason why the Olympus E-series digital SLRs are so popular with photographers looking to travel light.

The Pentax *ist D series of digital SLRs employ small sensors with a 1.5x magnification factor. These cameras accept multi-platform AF lenses as well as manual focus Pentax lenses. When manual focus lenses arc used, some camera features do not function, but the compatibility is still quite remarkable. Pentax has introduced a series of DA lenses, including a 12–24mm f/4, designed exclusively for their D-SLR bodies and optimized for digital capture.

Another manufacturer, Tokina, offers a line of multi-platform AF lenses. In addition, they have started a DX series of lenses for D-SLRs with small sensors. The first DX lens, the 12–24mm f/4 DX zoom lens, is currently available only with Nikon and Canon mounts, but the company will probably expand this line with additional lenses and other camera mounts.

Lenses For Compact Zoom Cameras

Digital cameras with built-in (fixed) lenses are everywhere, and for good reason. They're small, they're light, and they deliver amazing results at affordable prices. If there's one drawback to these cameras, it's that they don't offer interchangeable lenses.

As mentioned earlier, accessories are available for modifying the focal length of built-in lenses. Let's take a closer look at such adapters, sometimes called accessory lenses. Most of the camera manufacturers offer wide angle and telephoto adapters for at least a few of their high-end digital cameras. Aftermarket manufacturers (including Century Optics, Kenko, Phoenix, and Tiffen) offer additional adapters for modifying the lenses of various brands of cameras. Because these are adapters, they don't require autofocus or other electronics so they're smaller, lighter and less expensive than lenses for D-SLR cameras.

For photographers who want to see more, there are several wide-angle adapters on the market. A popular example is a 0.7x conversion lens (like Tiffen's MegaPlus model) that turns a 30mm equivalent lens into a 21mm equivalent focal length. They're useful for getting wider views of landscapes, interiors, or group photographs when the camera's fixed lens just won't provide a wide enough angle of view.

Telephoto adapters also are quite handy. They can multiply a normal lens' focal length and help make a moderate telephoto behave like its beefy cousins—only without the added weight, expense, and ultimate loss of light. (Notice how a faster f/2 telephoto is considerably more expensive than a slower f/4 telephoto. That's because it's harder to efficiently get a lot of light through a lot of glass.)

With telephoto conversion lenses, there's usually little or no loss of light passing through the lens. This allows the camera to set fast shutter speeds, making it easier to get sharp pictures when you handhold the camera; that's useful when shooting action, or if you're forced to work under low light.

There also are close-up adapters—designed to provide extremely close focus capability—that help make any lens more versatile. Although they have been popular since the pre-digital days, these "plus diopters" typically screw onto the front of a lens and allow you to get up close and personal with small subjects. (Think of close-up adapters as reading glasses for a farsighted lens.) Resembling filters with magnifying glass, these adapters are primarily intended for use with lenses for SLR cameras. Most compact digital cameras with built-in lens do not accept filters and already include a close-focusing "macro" mode. A lot more affordable than buying a whole new lens, these accessory close-up lenses do not reduce the amount of light entering the camera. Many lens and filter manufacturers market a variety of close-up lenses with different diameters, powers and surface coatings.

The Nikon FC-E9 Fisheye convertor is an extreme example of an accessory lens. With some cameras it can provide an angle of view of almost 180°.

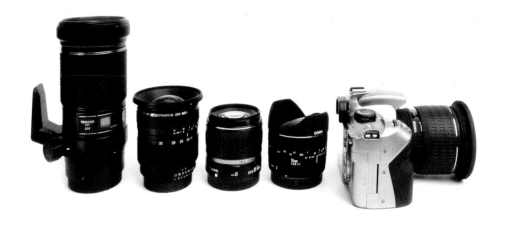

Get the Best from Your Lens

Here are some shooting tips to help you make the most of your lenses.

Text and Photography by Rob Sheppard

Get the Sharpness You Paid For

Many photographers end up getting photographs with less sharpness than the camera's sensor is capable of rendering from the lens. Although lenses are getting better and better, they cannot perform miracles, compensating for poor shooting technique. With a high quality lens on a compact digital camera or an SLR, your photos should be sharp. If they're not, the cause is probably a common problem: camera movement during the exposure. Many very good photographers don't realize that this doesn't just result in fuzzy photos, and the problem isn't always easy to recognize. The slightest camera movement can decrease image contrast so that the scene loses brilliance and snap, and no amount of "Photoshopping" will bring it back. Three elements can ensure you get the highest sharpness your camera can give: shutter speed, how the camera is handled, and camera support.

Just because a digital camera is easy to handhold doesn't mean it produces its best results that way. Unfortunately, the LCD screen can be misleading and give the impression that the photo is sharper than it is because the display is so small. You must magnify the image to really evaluate sharpness. And to truly see how a shot compares with the best possible from a camera/lens combination, you must compare the handheld shot to one that was taken with the camera locked on a rigid tripod.

Set the Right Shutter Speed

In doing some informal tests with colleagues and in workshops that I teach, I've had people shoot handheld with a variety of shutter speeds, then shoot the same scene on a tripod and compare. Most people start having trouble matching the tripod when the shutter speed

drops below 1/125 second for a 50mm equivalent lens and much faster for tele-photos (even 1/500 second is often too slow for a super telephoto). If your camera or lens has a built-in image stabilizer, you may be able to shoot at 1/30 second with a 75mm equivalent lens or 1/125 second with a 500mm equivalent lens. Even then, you'll probably get sharper pics by bracing your elbows on some firm support.

Considering the rules of thumb above, you'll often want to shoot at fast shutter speeds whenever possible if you're hand-holding the camera—particularly with long lenses. In bright light, the camera will often give you adequately fast shutter speeds at ISO 100 or at ISO 200 if you're using a moderate telephoto lens, such as a 300mm equivalent. On overcast days, you may need to select ISO 400 to get adequately fast shutter speeds and in dim light, even ISO 800 may not be adequate.

But with any camera/lens combination, image quality is always best at low ISO settings, with less digital noise to degrade image quality. So if you insist on shooting without a tripod, it's a trade-off. You can shoot at a low ISO for images without noise, but they may be blurred by cam-era shake. Or you can select high ISO for greater sharpness, and tolerate the more prominent digital noise pattern.

Brace the Camera

At all shutter speeds, it's important to hold the camera securely and then firmly press the shutter. Never punch a shutter, as that causes the camera to bounce, def-initely creating sharpness issues. Cameras need to be held with both hands, and as securely as possible for the camera's design. Tuck your elbows in close to your sides for more stability. Compose through the viewfinder, with the camera held firm-ly to your face. When light levels drop,

and whenever you want to ensure the utmost quality from your camera's sensor and lens, use a tripod. There are folding tripods for small cameras that will fit in a carrying bag; these can be fine, but be sure the tripod feels stiff and stable, not bouncy. They can be set up anywhere—on a table, a rock, against a wall and so forth—and will help a lot, especially if you do not extend the legs or especially, the center column.

Beanbags are quite handy, and will fit most camera bags. They provide a soft medium that fits between the camera and a hard surface, such as holding a rock, the roof of a vehicle, a railing or a fence post. Adorama markets a neat accessory, The Pod, which is like a beanbag, with a tripod screw that allows you to firmly attach the camera to the pod.

Then, of course, there's the tripod. A tri-pod can be a pain since it's another thing to carry, but there's no question that a tri-pod will help you get the most out of your lens. When looking for a tripod, open it up completely and see how stiff and sturdy it feels. A flexible, bouncy tripod will cause you problems with camera movement. In addition, see how securely you can lock the tripod head and legs. Be sure the head is easy for you to work, too.

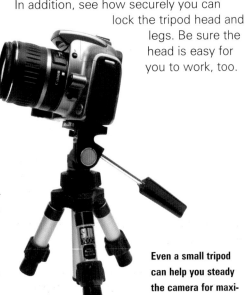

Even a small tripod can help you steady the camera for maxi-mum image sharpness.

You can see the difference a tripod makes in these images. Don't just glance at the image on the LCD. When viewed on the tiny monitor, a blurred photograph may appear sharp. Instead, be sure to zoom in to an area of small detail when reviewing the image to confirm that it's sharp. If in doubt, reshoot!

with a tripod **without a tripod**

Select the sturdiest tripod that you are likely to carry around frequently. A huge tripod may be more rigid, but it won't be of much value if you frequently leave it at home because it's too heavy to carry around. Avoid raising the center post of any tripod in order to maintain the most stable support.

Lens Angle Of View

Most people select a lens—or a camera with a built-in lens—based on the angle of view the lens offers. How wide is the lens? (In other words, how wide is the angle of view that it covers?) How much of a telephoto effect will it produce? (How narrow is the angle of view?) The answer depends primarily on the focal length. The short setting of an 18–200mm zoom lens provides a much wider angle of view than the longest setting.

The concept above is an important consideration. If you're traveling and expect to be inside small spaces that need to be

photographed, nothing but a wide (or ultra-wide) angle of view will do. If you're photographing a soccer game where the action takes place from near to far, you'll need a zoom lens that provides a whole range of angles of view. If you're photographing wildlife, a telephoto is critical.

This is more than a subject consideration, though. It's easy to be trapped into shooting with one focal length for a particular subject, even though your zoom has more possibilities. Everyone shoots the soccer game with the telephoto angle of view, for example, yet a wide-angle shot might be very appealing by showing off an interesting setting for the game. The wide-angle view of a cramped interior might be the best overall shot, but perhaps zooming in with a narrow angle of view can suddenly help you find details that would have been missed otherwise.

The best way to deal with this is to take the shot first with the focal length that seems best suited for the subject. Then try an extremely different focal length—a

Above: This street scene in Japan was photographed with a wide-angle lens on a digital SLR.

Below: A telephoto lens lets you fill the frame with your subject when you can't physically get close.

telephoto for cropped-in details, a wide-angle to include several elements or the entire environment. A portrait illustrates this idea well. First, take the shot with the moderate telephoto focal length (such as 80–100mm in 35mm terms). Afterwards, from the same position, look at what a wide angle of view gives you; then try a more extreme telephoto zoom setting. At this point, don't move—use your focal lengths strictly to illustrate how much or how little they will show of the subject.

Perspective

Perspective is a major image control, affected by lenses and heavily used by pros. We can define perspective as the size and depth relationships of objects within a picture. If two rocks (at different distances from the camera) are photographed so that they look similar in size

and appear close together, then the perspective is flat or compressed. This effect is common in images made with telephoto lenses. Imagine a photograph that depicts those rocks so the near one looks huge, while the more distant rock appears tiny; note too that the distance between them seems unusually great. This image exhibits deep perspective and was probably made with a wide-angle lens. Knowing how to control perspective with lens choice is a useful photographic tool.

It's important to note that simply changing lenses doesn't alter perspective. Perspective is based on distance plus focal length. If you photograph a scene with a telephoto lens and then with a wide-angle lens, then enlarge the center of the wide-angle shot to match the crop of the telephoto, you'll discover that the perspective is the same. And yet, in practice, perspective does tend to differ in images made with long versus short lenses. That's because we usually use telephotos for distant subjects and short lenses for nearby subjects.

A Perspective Assignment

The next time you're out, find a scene that includes rocks at various distances. Plan to take two photographs, one with a wide-angle focal length, one with a telephoto (this can be done with any camera that has a zoom). The trick is to take both photographs so that the foreground rock is the same size in both shots. This requires you to move in close with the wide-angle shot; since the lens will "see" more of the scene, the rock will be small until you get much closer. Afterwards, you'll need to back up with the telephoto, because the high magnification of the lens will make it much too large for this exercise. In both cases, moving to an appropriate distance (to or from the subject) will be necessary to keep the rock the same size in the two images.

When you examine the two photos, you'll discover some magic has taken place. The foreground rocks are the same size, but the background rocks are not! The wide-angle shot makes the more distant rock appear to be much smaller than you remember. Meanwhile, the telephoto shot makes it seem much larger than it was, in relation to the first rock. This is an excellent example of changing perspective.

There are many things you can do to affect perspective. Suppose you want to take a portrait in front of a dark doorway, but the doorway is too small. Back up and use more of a telephoto focal length to enlarge the door compared to the subject. Or maybe you want to make your local highway look like Los Angeles at its worst. Get out that telephoto to compress the distance between cars.

The photo on the left was shot with a telephoto lens and the one on the right with a wide-angle lens. Also, the position of the camera was changed so the bird perched on the light is approximately the same size in both photographs. Note how this affects the relative size of the other objects and the apparent distance between objects.

For the opposite effect, use a wide-angle lens to put some distance between your subject and its background. To make your subject appear dramatic and big, move in close with a wide-angle lens. The background will appear to recede; distant elements will seem to be very small and extremely far away. You also can do things like "stretch" a car or make a house look longer. As a portrait technique, this can make people's faces look odd, but it can be fun, especially with kids and pets.

Magnification

This is a variant of angle of view, but it's worth considering. A long lens produces images with high magnification and a narrow angle of view while a short lens produces the opposite effect. Sometimes,

Switching from a wide-angle (top) to a telephoto lens can have a dramatic effect on your photograph. Distant subjects appear to be magnified by the telephoto's narrow angle of view. Use a zoom lens to explore these types of compositional alternatives.

you really do want to think about magnifying a view, whether that's getting tighter framing of a tiger at the zoo or filling the frame with an architectural detail in the ceiling of a cathedral. The only way to do this is through increasing magnification, because you can't physically move closer to such subjects.

It's worth considering that most digital SLR cameras have a built-in magnification factor when using lenses designed for 35mm cameras. As explained earlier in this chapter, these cameras' sensors are smaller than the "standard": a 35mm film frame. Consequently, a D-SLR becomes a different format, just as 35mm is a separate format from a medium-format camera; it's also much smaller in size.

Whenever you compare two distinct formats, one has a smaller image area. If you use a lens from a larger format camera, only the center part of a focal length will be used to capture the image. This results in a magnification of the image within the format's frame.

We often discuss the focal length magnification factor as it applies to D-SLR cameras, but it also applies to digital cameras with built-in lenses. The effect is even more dramatic, because their sensors are extremely small. That's why you see zoom lenses with unusually short focal lengths such as 5.8–23mm on the Canon PowerShot A510, for example. With this camera, that 5.8–23mm lens is equivalent to a 35–140mm lens in terms of 35mm format cameras.

Depth Of Field

Depth of field is the range of acceptable sharpness in a photograph, extending in front of the subject and behind it. Four factors affect the range of sharpness: the lens f/stop (aperture) in use, the distance from the camera to the subject, the size

The dark, distracting lines in the background of the wide-angle shot (top) have been blurred and diminished in the telephoto image (bottom). The longer focal length and increased camera-to-subject distance produced the narrower depth of field. Depth of field is one of the most creative controls available to a photographer. Mastering it will improve your pictures.

of a print, and the focal length of the lens that was used. Here is a brief explanation of these items:

- **Aperture or f/stop:** Small lens openings increase depth of field; the larger the f/number, such as f/16 versus f/4, the smaller the aperture and the greater the depth of field.

- **Distance:** The farther you are from the focused subject, the greater the depth of field will be.

- **Size of print:** A small print of an image appears to have greater depth of field than a large reproduction of the same image; in a large print, any lack of sharpness is more obvious.

- **Focal length:** This is an important factor in affecting depth of field and can be used for extensive photographic control. Many photographers don't realize that even with a small point-and-shoot camera, they can adjust depth of field by changing their zoom from wide to tele. Wide-angle lenses (short focal lengths) give greater apparent depth of field while telephoto lenses (long focal lengths) reduce depth of field.

Depth of Field with a Digital Camera

As mentioned earlier, small digital cameras have very short focal length lenses (such as 7–21mm). This means that their photos will exhibit more depth of field than photos taken with bigger cameras, such as digital SLRs, used with the more typical (longer) lenses such as the 28–80mm zooms.

When you use a small camera with extremely short lenses, you can reduce depth of field by zooming to longer focal lengths and by using wider lens openings (f/4 instead of f/11 for example) when possible. Even at the widest aperture and the longest focal length, the very short zooms (such as 7–21mm) still provide images with quite extensive depth of field.

When you want to make an image with sharpness from nearby elements to a more distant background, use the wider settings of your zoom or change to a wide-angle lens (including accessory wide angle lenses or adapters). In other cases, you may want to limit sharpness through a selective focus technique (where one element is sharp and everything else is out of focus—an excellent technique). In that case, try using a telephoto zoom setting or a long lens or a telephoto adapter.

These aren't just techniques to use when photographing expansive scenes like a landscape or a city street. The ideas apply to photographing everything from close-ups to portraits. Extreme close-ups of a tiny blossom for example, change dramatically when the depth of field is adjusted.

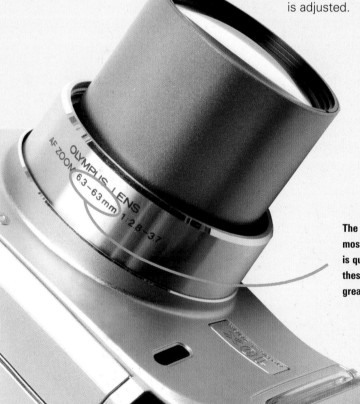

The actual focal length of most digital camera lenses is quite short. Therefore, these lenses provide greater depth of field.

Experiment

I'm a great believer in experimenting with focal lengths. Even though I've been photographing for many years, with many cameras and lenses, I still like to play around and see what my lenses can get.

The two photos below, taken on a single street corner in Kyoto, Japan, look quite different. The top image was shot with a telephoto (about 200mm), and the bottom image with a wide-angle (about 28mm).

Set the focal length first and then find a picture that works within its confines. It's a fun and useful exercise.

better flash photography

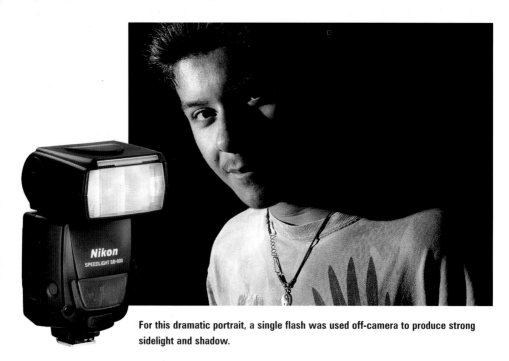

For this dramatic portrait, a single flash was used off-camera to produce strong sidelight and shadow.

Flash has come a long way from the old days when photographers were required to make complex calculations to get a good flash exposure. Now, almost all digital cameras with a built-in lens also include a built-in flash with an automated metering system. These cameras typically employ a flash-metering system that bases the amount of flash output on subject distance. That's not a very sophisticated method, but it should let you take good, to very good, flash photos. Flash can be used at several or many shutter speeds in just about every camera operating mode. Flash exposure compensation is common in most high-end cameras.

Many prosumer-level cameras with a built-in lens also accept a large accessory flash unit, which offers greater power for more distant subjects. The operation of a compact camera's accessory flash unit is similar to a built-in flash unit; however, the external flash may allow for bounce-flash photography, a technique discussed later.

Digital SLR cameras' flash systems are more sophisticated than compact and prosumer models, as you will discover in the following series of articles. They offer greater versatility, particularly with one of the high-tech accessory flash units that's great for achieving pro caliber lighting effects.

Lighting the Way

Understanding the fundamentals of flash will help you make the best purchasing decision.

By Ibarionex R. Perello

When it comes to flash, it's easy to consign its use for night when there isn't enough light. However, the real power of flash lies in its ability to improve the quality of almost any photograph, whether it is shot at twilight or midday. More than just a source of illumination when light is lacking, flash is a phenomenal tool for affecting exposure, contrast, and color.

This has become all the more possible—and particularly convenient—with the technological advances made by camera and flash manufacturers. A flash unit for a D-SLR camera isn't an afterthought, but instead an integral part of a complete exposure system. In the case of the recent Nikon D70s, for example, distance information from an AF Nikkor lens combines with the camera's 1,005-sensor meter and pre-flash data from an SB-800 AF Speedlight to produce an accurate exposure. The wonder is that all of this happens by just turning on the flash unit.

Supplementing your camera with an auxiliary flash expands your creative possibilities. By understanding the difference such a tool can make in your photographs, you'll find it easier choose the flash unit that best suits your needs.

Built-In Flash vs. Accessory Flash Units

A built-in flash can be the ultimate convenience; simply activate it and take your picture. Despite the small size, a built-in flash can illuminate a subject that's up to approximately 12 feet (3.6m) from the camera, at ISO 100; that's adequate for most shooting situations. Built-in flash doesn't offer enough power for more distant subjects, however.

Many digital cameras offer the convenience of a built-in flash. However, if you really want to learn about flash photography and take better pictures, invest in a dedicated accessory flash unit.

A flash's power rating is described in the form of a guide number (GN). The number doesn't reflect how far the flash will reach, but rather helps to calculate that distance. There's an old formula (GN \div f/stop = Distance at ISO 100) that used to be a photographic "must know" because flash exposures had to be calculated manually. Now the camera handles it automatically. Even so, the formula can be useful for estimating the effective range of a flash unit if you know its guide number. An average built-in flash has a GN of around 43 in feet (13 in meters). Applying the formula, you can assume that the flash unit will have a range of about 11 feet at f/4 when shooting at ISO 100. At higher ISO settings, the effective flash range is greater: roughly double at ISO 400, for example.

When comparing guide numbers of auxiliary flash units, it's important to note the flash's zoom head setting. Some manufacturers report the guide number with the zoom at a 50mm lens setting, while others use a higher zoom position. For example, the Sunpak PZ40X has a GN of 105 at a zoom setting of 50mm, while the Sigma EF 500 DG Super sports a GN of 165 at a zoom setting of 105mm. That makes actual comparison very difficult. Both units are quite capable of delivering light to a subject more than 30 feet away. So when comparing flash units, check the zoom setting to ensure a fair comparison.

In addition to offering more power, some models may include the ability to rotate and tilt the flash head for bounce flash effects; some also include a built-in adapter for the greater coverage required for ultra-wide-angle lenses. They also may feature wireless off-camera flash capability with certain camera models, high-speed sync, and stroboscopic modes.

Flash-Exposure Compensation

While the automatic capabilities of today's cameras often deliver excellent results, we may prefer a specific look in an image, perhaps by using either higher or lower flash output. This is achieved by using the flash-exposure compensation tool, available with many cameras as a built-in feature and also available on some accessory flash units. Typically, this allows you to increase flash output by up to one full stop or reduce it by as much as three stops in one-third stop increments.

This function is most useful for reducing flash output (with a minus factor setting), in order to make the result appear more subtle, usually with a gentle burst of light that fills in shadows. In strong backlighting however, you may find that you need to increase flash output (with a plus factor); this tactic can prevent underexposure which is common in strong backlighting, even when flash is used.

The camera's built-in flash is very convenient and easy-to-use. Some are surprisingly powerful as well.

The Fill-Flash Difference

We know instinctively to activate flash at night, but we may not consider its use under bright, sunny conditions. The extra burst of light can improve the quality of a photograph by reducing contrast and bringing out details and color.

Don't worry about overwhelming a subject with flash because it's significantly less powerful than the dominant light source, the sun. When you use a flash unit that's fully compatible with your D-SLR camera, the metering system calculates and adjusts ambient exposure and the output of the flash to achieve a balanced fill-flash photograph.

In a portrait of a person wearing a wide-brimmed hat at noon, for example, harsh shadows appear beneath the hat, obscuring facial details. By using fill-flash, the extra light reveals the details of a subject's face as well as the color. Even a backlit scene that typically results in a silhouette is enhanced to reveal subject details when using fill-flash.

Understanding TTL

Through-the-lens light metering (TTL) is available in all types of SLR cameras and in a few of the prosumer digicams with built-in lenses. This is a useful technology that allows cameras to achieve accurate flash exposures. Basically, the light emitted by the flash reflects off the subject and back to the camera. The reflected light passes through the lens and hits a light-metering sensor. When it is determined that sufficient light has illuminated the subject, the flash is quenched.

Today's digital SLR cameras offer significant advances over this basic concept. Cameras now can include evaluative (multi-pattern, Matrix, etc.) flash metering; some can incorporate distance data plus information from a pre-flash in order to minimize the risk of over or underexposure with black or very bright subjects. Some cameras can also employ data from the autofocus system to bias exposure for off-center subjects.

The bottom line is this: Whether utilizing built-in or auxiliary flash, today's D-SLR cameras have made it easy to capture good flash exposures both indoors and out. Simply turn it on.

Bounce and Off-Camera Flash

The look of direct, on-camera flash can appear flat and harsh; that's why many photographers often choose to bounce the flash or diffuse it through a translucent material. Both techniques soften the light by spreading it over a wider area. Although it reduces the effective range of the flash, diffusion creates a difference in the quality of the light that is often more pleasing for many subjects, particularly people.

Bounce flash is achieved by rotating or tilting the flash head toward a white surface, such as a wall, ceiling, or a large reflector panel. It's important to make sure that the surface has no color cast, because any color would have an impact on your final image. A unique feature is included with the Metz 54 MZ-4 flash; a secondary flash in its body provides fill light when the main light is bounced from a ceiling, adding catch lights to the subject's eyes and brightening the eye sockets.

You also can remove flash completely from the camera either using a dedicated TTL cord or using a wireless system. For the latter, use a camera/flash unit combination that supports wireless off-camera flash metering; you'll find that the flash unit will maintain full functionality. The remote flash unit(s) can then be positioned virtually anywhere within a reasonable distance from the camera.

Above: Direct flash results in harsh light that causes bright reflections on the subject's face.

Right: Bouncing the flash off a low, white ceiling spreads the light over a wider area. The result is a softer photograph.

For the look of studio lighting, position a flash unit behind your subject to add background glow. With wireless flash control, you can trigger the flash unit without a cable.

Wireless Controls

At one time, the position of an off-camera flash was limited by the length of a cable. Now, we can achieve cordless camera-to-flash distances of more than 30 feet (9 m), as well as use multiple remote flash units simultaneously.

Unlike studio packs, which are heavier and more costly, portable flash units offer incredible convenience and portability (although they don't provide as much power). Many systems now offer TTL capability with sophisticated light metering provided by the camera, eliminating the difficulties of determining exposure.

Assembling a multiple flash setup with wireless remote flash units allows you to create a portable studio virtually anywhere with the results immediately displayed on your digital camera's LCD monitor. This displayed image provides immediate feedback on the placement and output of each of the flash units. Take a test shot and evaluate it in Playback mode, using the information to set flash exposure compensation or make any necessary adjustments to the location of the flash units to achieve the desired effect.

Even non-dedicated (non-TTL) slave flash, such as the Nissin Digislave or Phoenix D91-BZS, can be used off-camera. (The

remote unit is triggered by the burst of light from an on-camera flash.) They're an affordable alternative for achieving a multiple-flash setup but without the sophisticated flash exposure metering discussed in the previous section. They work best when you use an accessory flash meter to determine the correct settings.

High-Speed Sync

The top flash sync of a D-SLR camera has typically ranged from 1/125 to 1/250 second. A few models even provide a flash sync as high as 1/500 second. This is the top shutter speed that ensures that the flash illuminates the entire image sensor. A faster shutter speed would result in the shutter partially obstructing the CCD at the moment of exposure.

High-speed sync allows shutter speeds as high as 1/2000 second, 1/4000 second, or 1/8,000 second depending on the digital SLR camera that you use. While it's unlikely that you'll ever need such a fast shutter speed in flash photography, high speed sync is a great benefit when you want to perform fill-flash under bright conditions using a wide aperture, such as f/4 for shallow depth of field.

Add a diffuser, such as the Lumiquest UltraSoft diffuser, over the flash head to produce softer light. This type of lighting is especially flattering for photographing people.

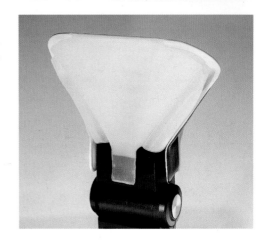

Flash Accessories

When using flash under such lighting with a nearby subject—with the conventional slower sync speed no faster than 1/250 second—the background is commonly overexposed if you select a wide aperture. To avoid overexposure, the lens might need to be stopped down to its minimum aperture, f/22, for example. You may not always want to use such a small aperture, however.

High-speed sync allows the use of higher shutter speeds by emitting light in the form of rapidly repeating flash bursts barely perceptible to the human eye. Although the effective range of the flash is reduced, it provides the means to use fill-flash and wider apertures for nearby subjects under bright conditions.

You can supplement the capabilities of your flash with a variety of easy-to-use accessories. The LumiQuest UltraSoft diffuses light produced by your flash. It enlarges and redirects the flash at a 90-degree angle and softens the light by passing it through a frosted diffuser. This reduces the harshness of shadows and delivers softer, more pleasing illumination.

Even if you're using only one flash, adding a reflector provides studio-like control of your lighting. Position the flash unit on one side of your subject and place a reflective card or fabric panel (preferably a large one) on the opposite side to create a pleasing fill-light. Reflectors are available in sizes from 12 inches to 52 inches (30 to 132 cm), with dual reflective surfaces including soft/gold, gold/silver and silver/white.

The Quantum Turbo Compact battery ensures that your flash has power when it's needed. The powerful rechargeable battery supplies consistent and reliable power to your flash along with a fast recycling time. The compact battery includes easily readable LEDs for quickly checking battery capacity.

Off-Camera Flash

Use flash to control the light in your pictures.

By Ibarionex R. Perello

The previous article briefly discussed the use of bounced flash and off-camera flash, but it's worth considering both topics in additional detail. Whether it's a wireless remote flash or a unit tethered to the camera with a dedicated cord, an off-camera flash provides an assortment of lighting options. Bounce flash creates a nice diffused light that eliminates hard shadows on your subject and background.

Bounce Flash Techniques

By pointing the flash head at a white ceiling of average height, you can produce a soft light that simulates the illumination of an overcast day. Bounce the flash light off a wall beside your subject and create the appearance of window light. (Make sure that you select a bounce surface that's white or very close to white, to prevent unwanted color casts in your images.)

Even when working in the field, you can create similar results by firing the flash into a small reflector set to bounce the light toward the subject. This is particularly effective when doing close-up work. I find that the resulting fill light is much less contrasty and pronounced than it would be with direct flash.

Off-Camera Flash Techniques

You don't always have to bounce the flash to create an interesting effect. For outdoor portraits when using fill-flash, I'll often use a straight forward off-camera flash technique, holding the unit slightly above the subject and to the left or right; sometimes, I'll narrow the flash's zoom head as well. Although I'm using a wide-angle lens, I'll set the zoom head to 85mm. The narrow beam of light is isolated to my subject's head and shoulders.

The off-camera flash produces dramatic sidelight and allows some of the subject to fall into shadow. Using a TTL-dedicated cable, the flash maintains full TTL functionality for this fill-flash effect at dusk.

This delivers a great effect, especially for a portrait at sunrise or sunset.

Not all D-SLR cameras and flash units support wireless off-camera flash. However, most D-SLR cameras with a hot shoe for accessory flash do allow you to take advantage of wired off-camera flash. This is achieved by connecting the flash unit to the hot shoe using a TTL off-camera cable designed exactly for that purpose; most SLR manufacturers offer an accessory of this type. When connected, you'll be able to not only fire the flash, but also maintain advanced flash features such as second-curtain sync. Many such cords have a tripod socket on the base so you can secure the flash to a tripod or light stand.

Wireless off-camera flash—with D-SLR's and dedicated flash units that support this feature—can be just as effective. (With this technique, on-camera flash or an accessory controller unit automatically triggers the remote flash unit.) Be sure to study your camera owner's manual and the manufacturer's web site to determine whether it's suitable for wireless off-camera flash. If it is, you'll also need to determine which specific flash units will be fully compatible for this purpose. Again, the manufacturers' web sites should provide the necessary information; also plan to consult a knowledgeable photo retailer.

Regardless of the technique you use to avoid (harsh, unflattering) direct on-camera flash, you'll find it worthwhile to take greater control of light. With a bit of experimentation you'll be able to find just the right technique that will provide you with the opportunity to create some very distinct and wonderful images.

A Flash in the Night

Create dramatic evening images with a touch of artificial light.

By Ibarionex R. Perello

Although low-light flash photography was discussed in the previous articles, let's take a closer look at creating exciting images at night with electronic flash, an indispensable tool. Stunning results are possible by simply using a camera's built-in or auxiliary flash unit. Yet there's so much more that you can do with a flash beyond merely turning it on.

There's no reason to be intimidated about using flash. The TTL (through-the-lens) metering systems of today's D-SLR cameras make it incredibly simple to get well-exposed flash images automatically. Just because it's automatic, however, doesn't mean that the images have to be boring. Flash pictures can be just as compelling as any photo shot under the sun.

High-Tech Flash Metering

In the traditional TTL systems discussed earlier, the flash is discharged and the light reflected off the subject returns to the camera through the lens and hits a sensor within the camera body. Based on the ISO sensitivity, the camera quenches

the flash as soon as it has determined that sufficient light has illuminated the subject; all of this occurs within thousandths of a second.

For more precise flash exposures, many of today's digital SLR cameras utilize a series of pre-flashes to evaluate the flash intensity that might be appropriate when the picture is actually taken. Combined with subject distance information provided by the autofocus system, the metering computer compensates for subjects that are very dark or very light in tone.

Because the camera's software knows what a normal flash output would be at a given distance for a neutral subject, it can adjust for extremes such as white or black subjects that reflect dramatically more or less light, respectively. Since most of this is handled invisibly, you don't have to worry much about it. The only thing that's important when using an auxiliary flash unit is to make sure that it's set for TTL mode.

By using a slow shutter speed as well as the flash unit's Slow Sync function to capture the ambient light, a streaking effect appears behind the truck. This creates a natural and dynamic image of movement and light.

Improving Background Exposure

If you've been shooting images for any period of time, you know what a standard flash photograph looks like: bright foreground and dark background. There's nothing bad about this; often, it's all that you need for photographs taken at an event like a birthday party or an awards ceremony. Yet, you may want to make some images that reveal more of the background; to do so, you don't need a more powerful flash, but rather a slower shutter speed.

Most photographers tend to use a very fast shutter speed—called synchronization or sync speed in flash photography—such as 1/60 second, 1/125 second, or even faster. Due to the incredibly short duration of the flash, the nearby subject is well lit but the background is usually dark. This is typical especially when the background is quite far away and is not well illuminated by ambient light, such as with night photography.

The best way to solve this problem is to select a much longer shutter (sync) speed, such as 1/15 second. Depending on the camera, you can achieve this by using the Shutter Priority AE mode or one of the Program options such as Slow Sync flash or Night flash mode often represented by a lightning bolt symbol and the word "slow."

The Program option is the simplest and most convenient; the camera will automatically choose a slow shutter speed and it will also fire the flash. During the longer exposure, there's enough time for the darker background to register so it's much brighter than it would be in more typical flash photography. Your nearby subject is nicely illuminated by a brief burst of flash. The result is a balanced image with a good flash exposure and a well-detailed background.

Rear-Curtain Sync

Also useful when using a long shutter (sync) speed in flash photography, Rear-Curtain Sync is a feature that's available with some cameras, using the built-in flash or a dedicated accessory flash unit. Select this option and the flash will fire at the end—rather than at the beginning—of the long exposure time. The difference is readily apparent when shooting moving subjects.

If you make a standard flash (front curtain sync) exposure with a moving subject, the flash will fire at the start of the exposure. As a result, motion streaks will appear in front of the subject. That's not a natural looking effect. Because Rear Sync delays the firing of the flash until the end of the exposure time, the motion streaks appear to follow the subject, a more natural effect. This can produce striking images, especially when panning: moving the camera at the same speed as the subject's motion. That can produce in bright, backgrounds full of almost surreal hues.

With either conventional or Rear-Curtain Sync you can handhold the camera, but you'll get blurry backgrounds because of the long exposure time. If you wish to render the background with full detail and sharpness, put the camera on a tripod. Handholding—especially while moving the camera—can give wild, edgy effects, but they aren't for everyone.

Flash-Exposure Compensation

Even when using the most sophisticated TTL flash system, you may not get exactly the results that you want. Just as you might use flash exposure compensation in daylight, you may need to use this feature in flash photography at night. Make a minus (–) setting for less intense flash output if you prefer a more subtle lighting effect. Switch to a plus (+) setting for a brighter rendition or to create a fashion-style look, where skin tones can be slightly overexposed, reducing the appearance of blemishes. You may also need to move closer to the subject; if the flash has already reached its maximum output, a + compensation setting will not produce any more light.

Off-Camera Flash

One of the most dramatic ways of making your nighttime flash images look distinctive is by taking the flash off the camera using one of the techniques discussed in the previous article. This will produce directional light that illuminates subjects in ways that reveal depth, rather than the flat look that's common with most flash photographs. Position the flash at an angle, either handheld or mounted on a light stand, and it can produce sidelight that allows the opposing side to fall into the shadow, creating a sense of depth.

Off-camera flash is also an effective way of eliminating shadows on the background created by the subject when the flash is coming directly from the camera's position. By situating the flash higher than the camera, the shadow will be cast lower, behind the subject, and won't likely appear in the final photograph.

Bounced And Diffused Flash

Another way to change the quality of the light emitted by flash is by bouncing or diffusing the light. For example, by using a diffuser over the flash head, you can soften the appearance of the light when working with close-up subjects. The harsh look of flash can be markedly reduced. Remember however, that the effective range of flash will be reduced, so at night, this technique is most useful with nearby subjects.

Bouncing the light from an accessory flash unit (with a swivel/tilt head) into an umbrella, a white ceiling, or a wall can also produce a diffused source of illumination. When bounced off a reflective surface, the light is spread out (diffused) and produces a softer, more even illumination, which can be particularly flattering for portrait subjects. However, the diffusion that improves the quality of the light also reduces its effective range, so your subject may need to be closer to the reflective surface than it might have been if you had used the flash straight on.

Bouncing the flash off of a white reflector softened the light used in this portrait taken in early evening. The diffused illumination wraps around the subjects' features without the harshness typically experienced with direct flash.

accessories for digital photographers

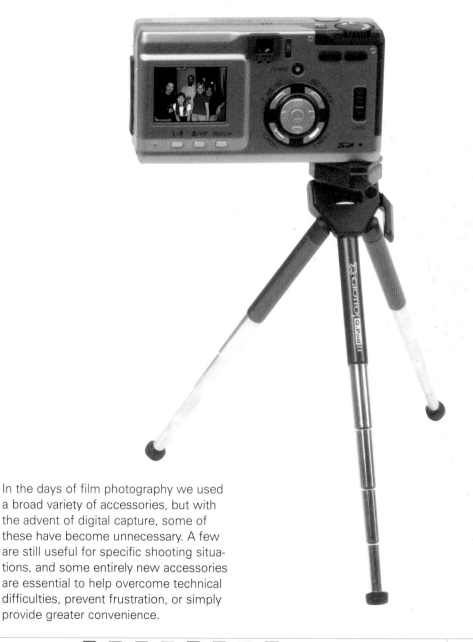

In the days of film photography we used a broad variety of accessories, but with the advent of digital capture, some of these have become unnecessary. A few are still useful for specific shooting situations, and some entirely new accessories are essential to help overcome technical difficulties, prevent frustration, or simply provide greater convenience.

An Overview of Photographic Accessories

There are a number of useful accessories for your digital camera.

By Wes Pitts

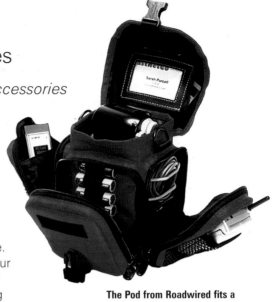

You've got your digital camera, so now it's time to outfit your gadget bag with all the accessories that make photography more successful and enjoyable. Whether you're shopping for gifts for your favorite photographer, outfitting yourself for an upcoming vacation, or just putting together a complete photo kit for everyday photo opportunities, we've compiled a list of the essential accessories to augment your digital camera's capabilities.

The Pod from Roadwired fits a compact digital camera and has a compartment for every accessory you could possibly carry.

Bags and Cases

The bag or case you choose to protect your camera and other photo gear is one of the best investments you'll make. You'll want to find a soft bag, hard case, or possibly both to help organize, transport, and secure your equipment.

Camera cases come in all shapes and sizes. You can choose the traditional over-the-shoulder design, the hip belt variety, or new designs that resemble a backpack or sling bag. Each "wears" and fits differently, so try them on before buying.

Make an inventory of the camera gear and accessories you carry, and choose a bag with enough pockets to keep everything organized and accessible. Some bags are designed with specialized compartments for all the usual accessories, including memory cards, batteries, and accessory lenses, while others offer movable partitions for custom storage configurations.

When choosing a soft case, emphasize accessibility and consider the details, such as how the main flap or compartment opens. Can you reach what you need with the camera bag still on your shoulder? Make sure the case you choose is comfortable and allows easy access to compartments while wearing the bag.

Depending on the number of accessories you have, you may want two bags: one large enough for everything and a smaller one in which you easily can carry just the essentials when on the go.

If you travel frequently with a lot of photo gear, consider a hard-sided case for transporting your gear. Durable, shock-absorbing, and water-resistant (some are even waterproof), foam-lined hard cases give your camera and lenses an added level of protection from impact and the often harsh treatment that luggage receives while traveling. Shiny aluminum models look great, but they're also attractive to thieves. Instead, we recommend a low-key black model.

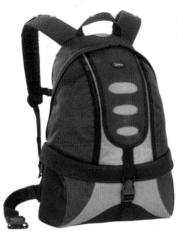

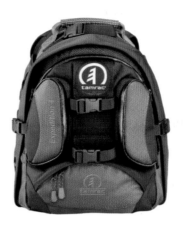

Do you want to bring your photographic equipment with you on hikes or when you travel? Photo backpacks, such as the Lowepro Orion Trekker II or Tamrac Expedition 4, are a comfortable way to carry photographic equipment.

When you're shopping for bags and cases, don't forget the most important accessory for carrying your camera—the neck strap. It may be something you overlook, that is, until you spend all day with a camera around your neck. Unlike the one that came with your camera, the neck straps you'll find in camera stores are designed to cushion the weight of your equipment for more comfort during extended use.

Tripods

Keeping your camera rock-steady is essential if you want to get the full sharpness of which your lens is capable. Most of us undoubtedly prefer to handhold our cameras, but unless you're shooting at a relatively fast shutter speed, you'll probably lose a degree of sharpness if your camera isn't mounted on a tripod or other support. A camera or lens with an image stabilizer is useful in many situations, but a tripod is more valuable when shooting in low-light situations or with very slow shutter speeds for creative effect.

Tripods typically are constructed of either aluminum or carbon fiber. Aluminum is heavier, but less expensive, while the carbon-fiber models are both lighter and pricier. Whichever you prefer, set the tripod to its full height at the store to be sure the tripod you choose is sturdy and rigid, and that it supports the camera system and lenses you use.

Look for a tripod that collapses to a size you can easily carry. Its minimum height when fully extended should be at your eye-level and it must be very solid, rigid, and stable. If you like to do close-up or low-to-the-ground photography, get a tripod with legs that can be splayed to various angles. Be wary of multi-sectioned tripods with narrow diameter leg tubes, however; these can be less stable than handholding in some cases.

Your tripod may or may not come with a head already attached. The common head types are ball heads and pan-and-tilt heads. Ball heads tend to be more expensive, as they can be more easily adjusted to a particular position quickly. Try a ball

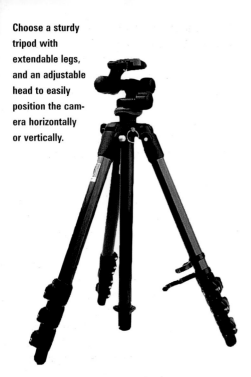

Choose a sturdy tripod with extendable legs, and an adjustable head to easily position the camera horizontally or vertically.

head and a pan-and-tilt head and see which you prefer before settling on one. Also, look for heads that have a quick-release plate, which makes it easier and faster to attach and remove your camera from the tripod head.

If you're interested in video, get a fluid head designed for video cameras. These dampen and smooth camera movements such as a pan across a scene.

Accessory Flash Units

Your digital camera probably has a flash unit built in, but it may not offer enough power or flexibility for your needs. An accessory flash can be a huge benefit when you need more light to illuminate both your subject and the environment.

Ideally, you'll choose a "dedicated" flash unit that's compatible with your camera's TTL metering system. This allows your flash and camera to work together to balance ambient light with the flash output

for more accurate meter readings and exposures. (Check your digital camera owner's manual as to the type of flash unit that provides full compatibility.)

As discussed in the Flash chapter, flash units are designated with a guide number, which indicates how powerful the flash output is. Stated in feet or in meters, the guide number does *not* denote the actual distance that flash can be used, but it can be useful for comparing the power of several flash units.

Other flash features to consider are the ability of the flash head to swivel, tilt, and to zoom automatically, using a built-in motor. Many flash heads allow you to tilt the light source up or down to bounce the flash off of a wall or other surface, which often can provide more pleasing illumination than head-on flash. Some models also allow you to swivel the head left and right for even greater directional control; use this feature for bouncing flash from a wall or an accessory reflector panel.

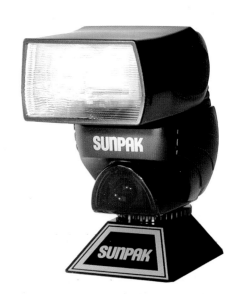

Use an automatic dedicated flash unit with your digital camera for easy flash photography.

Flash units with an automatic zooming function are especially nice, provided that they're compatible with your camera. With tho zoom feature enabled, the flash will recognize the zoom setting of your lens and adjust its output accordingly; this will help focus the flash output where you need it.

Accessory Lenses (Adapters)

Although compact cameras with built-in lenses usually include a 3x or 4x optical zoom, there are occasions when you'll want to extend that range for greater telephoto or wide-angle performance. Accessory lenses—actually adapters—allow you to do this. While not all cameras will accept accessory lenses, those that do give you a remarkable amount of flexibility for everything from wide scenics to tight telephoto photography.

These adapters are discussed in the chapter "Selecting and Using Lenses," but here are a few additional comments. In addition to the typical wide angle and telephoto adapters, you can also find a few specialty adapters, such as fish-eye lenses, and also, highly corrected achromatic lenses for superb quality in extreme close-up (macro) photography.

If your camera does accept them, your camera's manufacturer is the first source to check for accessory lenses (adapters). A wide variety of accessory lenses that are very high quality also are available from independent manufacturers; some of these even fit cameras that do not accept the manufacturers' own brands of adapters. Add just a few of these adapters to your compact camera system, and you can have most of the focal range choices that SLR users enjoy, for considerably less expense.

If you enjoy macro photography, consider adding some accessory close-up lenses or diopter lenses to your equipment collection. They'll allow you to focus on subjects that are quite close to the camera.

Beyond the Camera

Discover the accessories that will allow you to make the most of your digital camera.

By Ibarionex R. Perello

When you first buy a digital camera, the purchase generally includes a low capacity memory card and a set of batteries. These will allow you to take a few shots, but for long term use, plan to invest in a few useful accessories.

Memory Cards

Most new digital cameras include a modest 8 or 16 MB memory card. Yet, with most megapixel cameras at their highest resolution, such a small memory card will likely hold less than a half-dozen images. That's why purchasing higher-capacity memory cards is one of the most important investments you can make. The following card formats are common; most cameras accept only one format, although a few digital cameras accept two.

CompactFlash (CF)

CompactFlash offers the highest maximum capacity to date for digital cameras. Cards are available in capacities of up to 8GB (and soon, to 12GB), so they're ideal for use with professional digital SLRs that generate massive image files. The latest generation of cards is optimized for SLRs and provides superior read/write speeds with such cameras; a few of the recent high end compact digital cameras can also benefit from the higher speed of such cards. (Be aware that some compact cameras may not be compatible with very high capacity cards or the thicker Type II cards.)

Memory Stick

Introduced several years ago by Sony, and now made by several manufacturers, the Memory Stick is a very compact card that can be used in both Sony digital cameras

and video camcorders. These thin cards allow designers to make incredibly small cameras that boast a wealth of features. They're currently available in capacities of up to 256 MB. Most of the latest Sony cameras also accept the newer Memory Stick Pro cards.

Microdrives

These memory cards were the first to offer high-capacity storage in an accessory that is the same size as a CompactFlash Type II card: thicker than a standard CompactFlash card. Microdrives are actually miniature hard drives complete with moving parts. They're often less expensive than a com-parable-sized CompactFlash card and are compatible with most cameras that accept the Type II cards. Do note howev-er, the presence of moving parts makes them susceptible to damage from impact or shock. Also, many compact cameras do not accept Microdrives; check your owner's manual.

Whichever type of memory card your camera takes, make sure to have ample storage capacity for all the images you want to shoot.

SD And xD

Smaller than a postage stamp, these media cards provide a read/write speed that's often four to five times faster than conventional (non-high speed) CompactFlash cards. Their small size allows for more compact cameras than those using larger memory cards. With storage capacities of up to 512 MB for xD (with higher capacities in future) and 2GB for SD, these small cards are capa-ble of storing a large number of high-resolution images. Cameras that accept SD cards usually also accept the very similar MM cards. The latter do not offer the security features available with SD cards and may not be capable of the same high read/write speed.

Battery Power

Digital cameras are great consumers of battery juice, more so than their film-based siblings. The combination of a CCD or CMOS image sensor, color LCD moni-tor, high speed processor, image buffer, built-in flash and zoom lens makes a digi-tal camera a power-hungry beast. So the right choice in batteries can make the dif-ference between looking at a great shot or looking at a "low-battery" warning.

Alkaline vs. Lithium

Traditional alkaline AA batteries often are packaged with some new digital cameras. However, there are better choices when it comes to power for your camera. Because digital cameras quickly exhaust standard alkalines, you should consider the new high-power alkaline cells (Energizer e2 or Duracell Ultra). The Eveready lithium AAs last even longer and are the best power source from a dispos-able (non-rechargeable) AA battery. Some cameras that use AA batteries also accept the new CR2 lithium batteries, resembling two AA's joined together. Lithium's higher power capacity and reliable performance throughout its life make it preferable over

alkaline. It also provides great perform-
ance in colder temperatures, which is
something to consider if you expect to
shoot under such conditions.

Disposibles

These can serve as an excellent backup
to rechargeable cells if your camera
accepts both types; the disposables are
useful especially when you're in the field
and have no access to AC power for
recharging. Do note however, that some
charger kits for rechargeable AA batteries
include an adapter for charging in a vehi-
cle, using the cigarette lighter socket; oth-
ers offer that accessory as an optional
extra. You can also buy inverter acces-
sories that allow for powering small elec-
tric devices with AC cords (such as most
battery chargers) at automotive stores.

Rechargeable

Nickel-Metal Hydride (NiMH) batteries are
the most cost-effective batteries for cam-
eras that use AA-sized cells. Available up
to 2500 mAh, these cells deliver excellent
performance in both compact and SLR-
type digital cameras. They also perform
well under extreme temperatures and are
great for external flash units as well. The
old NiCd batteries may work too but they
have much lower capacity and technical
problems such as memory effect.

**Compact cameras may not have filter threads to screw
a filter to the lens. Instead, adaptors are available that
mount in the tripod socket.**

Proprietary Rechargeables

Most compact digital cameras accept
only a proprietary lithium-ion or NiMH bat-
tery designed specifically for one or two
camera models. You'll want to buy a
spare; we suggest that you buy only the
camera manufacturer's brand or another
from a well known name-brand company.
Whichever battery type you need, it's
worth owning three separate sets. One
will be in the camera, while the second
fully charged cell is in your camera bag
and the third is on the charger. By placing
them in this type of rotation, you can be
assured that you'll always have two fully
charged batteries available.

Filters

Filters provide the means for achieving
some wonderful digital photographs.
Although your computer is capable of
many things, filters may provide better
results. The first two are mentioned in the
Lens chapter, but the following additional
comments and suggestions should also
be useful.

Polarizer

A polarizing filter performs several func-
tions. It eliminates glare and thereby
improves contrast and color saturation; it
can also deepen the tone of a blue sky. If
glare is present in an image, detail in the
highlights is reduced or completely lost.
When this happens, there isn't much that
can be done for the image. But by using a
polarizer, a simple rotation of the filter ring
will eliminate the unwanted glare. By elim-
inating or reducing glare, this filter can
also produce richer colors.

Do note that a polarizer provides the max-
imum effectiveness when the camera is
at a 90 degree angle to the sun. If the fil-
ter is not effective, you may need to
change your shooting position. As you
rotate a polarizer within its mount, the
effect will change: from moderate to

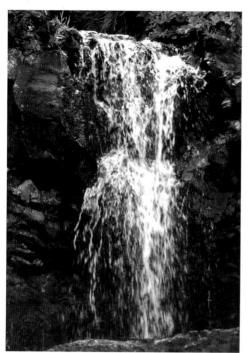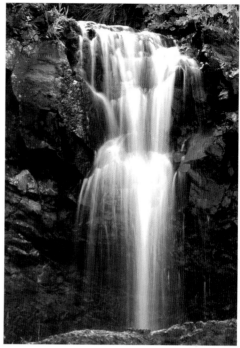

A fast shutter speed stops the water in motion (left). A slow shutter speed creates the effect of smooth flowing water (right). If the scene is very bright, using a neutral density filter will allow you to set a slow shutter speed.

more obvious. Watch the effect changing through the viewfinder of a D-SLR camera, on the electronic finder in some compact cameras or on the LCD monitor of other compact digital cameras. When the image looks just right, take the photo.

Neutral Density

Also called ND, this filter is a dark grayish filter designed to reduce the light reaching the camera's sensor. Its neutral color reduces light without impacting the image's color. Available in various strengths, the ND filter is used in extremely bright situations when you want to use extremely long shutter speeds. That may not be possible even at ISO 100 on bright days; the shutter speeds will be quite fast. An ND filter can reduce the light transmission by 3 f/stops, or even more, depending on the model you buy. (A polarizer is useful too for the same reason, but it reduces light transmission by only about 1.5 stops.) The

camera's built-in metering system automatically compensates for the loss of light produced by the filter.

Graduated Neutral Density

Similar to a neutral-density filter, the graduated neutral-density filter gradually transitions from gray to clear. Consequently, the darker section will block more light than the clear portion. A graduated neutral-density filter will allow you to control lighting in a scene to ensure that you have good detail both in the highlights and in the shadows. Although digital cameras can capture a wide tonal range, they're still subject to limitations. This filter is a great asset when you're photographing scenes with a large contrast range, for example, scenics; place the dark half of the filter over a bright sky so it will not appear as bright in the final image. Even if your camera doesn't have filter threads, an adapter can be attached to your camera via its tripod socket.

Protective Filter

Some photographers prefer a protective filter for their lenses. If so, we recommend that you purchase a high quality multi-coated UV or Skylight filter. Avoid the many cheap filters that are made of inferior glass or plastic because they will reduce the quality of your photographs.

Hoods for Monitors

Your camera's LCD monitor can serve as a viewfinder, but under bright conditions, your view of the screen can be obscured by glare. This can make it nearly impossible to properly compose your photograph or evaluate it for exposure during playback. The solution is to buy an LCD hood, an accessory that attaches around the LCD panel, blocking stray light from hitting your screen. This makes it easy to view the displayed image as well as to navigate the camera's menu screens.

There are a number of photographic accessories, such as this hood for an LCD monitor, that make the experience of shooting pictures more successful and enjoyable.

Using Graduated Filters

There's no digital substitute for this traditional photographic tool.

Text and Photography by Wes Pitts

For all of their surface differences, digital photography and traditional film photography have a lot in common. Case in point: good, old-fashioned lens filters. Despite the high-tech wizardry of which the digital darkroom is capable, it can't accurately re-create what the camera didn't record. There's no digital substitute for controlling the light before it enters the camera—only a lens filter can do that.

A prime example of what lens filters can do for your photographs, whether they be digital or film, is the graduated neutral-density filter mentioned earlier in this chapter. If you're not sure how a filter of this type works, or why you might want one, read on for additional specifics.

An ND Grad filter—clear on one half and dark on the other—is valuable whenever you're dealing with extreme contrast in a scene. Unlike the human eye, which can record and process a wide tonal range, photographic tools can capture only a very limited range of tones. So, if you're trying to photograph a subject in the shade with a bright sky behind it, you're going to end up with either a washed-out sky or a dark subject—that is, unless you use a graduated neutral-density filter to darken the sky.

I took these photographs of a train at Travel Town, a public park in Los Angeles dedicated to preserving artifacts from the golden age of railroads. It was a bright, sunny Southern California day. First, I composed a shot without a filter. While the train is properly exposed, the sky is

The scene had too much contrast. Adding a graduated neutral-density filter blocked some of the light from the bright sky to prevent it from being recorded as pure white.

blown out. Then I took the same shot holding an ND Grad filter in front of my camera's lens. I was careful to align the density transition of the filter with the boundary line where the train ends and the sky begins.

The dense (dark) half of the filter blocked some of the light from the sky, reducing the contrast of the scene and bringing the sky and the train into a tonal range that my camera could handle. You can see the difference it made.

If your digital camera has a threaded mount—or an optional adapter that allows you to attach filters—you can get a rotating neutral-density graduated filter that screws into the front of the lens like any other circular filter. The advantage of this approach is that it's convenient. Problem is, the filter is fixed in position so you won't have as much compositional flexibility, since the filter must be aligned precisely with the transition between light and dark in the scene. You may want a

rectangular ND Grad filter and a holder that screws into the front of the lens instead. This combination is far more versatile, because it allows you to move the filter to just the right angle and position.

For this example, I used a rectangular Singh-Ray "Daryl Benson" ND-3 Reverse Graduated filter that I hand-held in front of the lens. A Cokin Pro filter holder might have been even more convenient, but this approach worked well too. It allowed me to position the density transition anywhere I wanted to in the frame, giving me compositional freedom. If you choose this route, be sure you hold your filter totally flat against your lens or you may get stray reflections off of the filter's surface.

While digital cameras and software give us new levels of control over our images, digital photography is still photography, and many "old school" tools are just as important as ever. Learn to use lens filters for your digital photography and you'll get better results, guaranteed.

shooting tips

In previous chapters we have discussed the cameras, lenses, and accessories available for digital photography and have provided a few tips on using them effectively. Now, it's time for an in-depth look at some techniques for making images with great visual impact using the equipment to maximum advantage.

The Best Digital Camera Tips

In the years we've spent shooting pictures with digital cameras, we've learned a thing or two. Here are our top tips.

By The Editors

In the years since we've been producing *PCPhoto Magazine*, the editors have been in a fortunate position. When new products are introduced—everything from digital cameras to scanners to software to printers—frequently we have the opportunity to play with them. Not only that, but we even get paid to do it.

The editors at *PCPhoto* are photo-centric people. We take out gear and we use it to take pictures, and when we're not happy with the pictures, we try to figure out what we can do to make them better. Recently, we sat down and comprised a list of some of our favorite tips and techniques. These are brief so you'll find additional details about some of them in the subsequent articles in this chapter.

Stick to Optical Zoom

When you choose a digital camera, you'll notice that there are a couple of zoom figures listed on the box and other promotional material. One is the optical zoom and the other is the digital zoom. Typically, optical zoom is about 3x or 4x, while digital zoom can be closer to 10x and higher.

The difference between the two is that optical zoom is achieved through use of the lens elements while digital zoom is achieved by cropping in on the image sensor, then interpolating the resultant image file to higher resolution. For maximum image quality use only the optical zoom. The newest digital cameras on the market have vastly improved digital zoom algorithms than were available just a few years ago. These improvements make the digital zoom much more useful, but it's still a compromise.

Avoid Loss of Power

Batteries are a key issue for digital cameras. One of the worst experiences for a photographer is to be photographing and have the camera die with no chance of recovery. A good policy is to own three batteries (or sets) for your camera and a charger separate from your camera. This way, you can have a fully charged battery in your camera, a fully charged battery in your bag and the third battery on your charger. If you photograph during the day and use up most of the two batteries, you put the one from the charger into your camera and put a battery on the charger overnight. Then you have two fully charged batteries with you the next day and you put the last battery on the charger while you're out taking pictures.

Purchase extra batteries and a separate charger to keep your camera powered up.

Try a worm's eye view to accentuate the height of a tall building.

Try Unusual Angles

If we look at our images, we may see that a great number of them are shot with the camera at eye level. A whole new world can be opened to us when we pull the camera away from our face and try different compositions and angles.

A great way to experiment is to focus on a single subject and try every angle and position you can think of. Position the camera at various heights above and below your subject. Tilt the camera slightly to the left or right. Start with a wide shot and slowly move closer until you're filling the frame with some details of your subject. You'll soon discover that there's more than one way to take a picture of any subject.

Use Fill Flash During the Day

When you see a professional photographer working, you'll notice he or she uses a lot of flash. It's an easy and highly effective way to dramatically improve your pictures. Flash helps to soften or completely eliminate harsh shadows and adds emphasis to the main subject in your shot. This is especially useful when you're taking pictures of people.

Use Continuous Shooting Mode for Portraits or Close-Ups

A camera's continuous shooting mode was designed to help capture fast-moving action. Yet, it's a great tool for shooting portraits or close-ups because it can help to ensure a sharp picture.

Anytime you depress the shutter release button, slight movement occurs, which can have an impact on the image. This is especially a risk when working with a very shallow depth of field or a relatively slow shutter speed. By using the continuous shooting mode, the camera takes several almost identical pictures in quick succession. The vibration may impact the first shot, but the subsequent images are noticeably sharper. The trick is to maintain pressure on the shutter release button while you're taking the pictures. Although a tripod is always preferable, this camera feature increases the chances of having a tack-sharp image.

Flash isn't just for low-light situations. In bright sunlight, add fill flash to soften harsh shadows and decrease contrast.

Changing the white balance (WB) setting produces an effect similar to using a colored filter. With a little experimentation you'll learn how your camera's white balance settings can be used for creative effects.

By trying several compositions, you have a good chance of finding an even better photograph than the one you originally intended. You also get the opportunity to improve your photo skills by challenging the almost automatic response that we develop as photographers over time. It's easy to get into a compositional rut, and this is a creative way to break out.

Think of it as "sketching" a subject from as many angles as possible. Thanks to digital cameras, you don't have to worry about wasting film with such an exercise. Shoot as many images as you like until you feel you've exhausted the possibilities. You can always delete the shots that don't work.

Bracket Your Exposures

If you're not familiar with the term, bracketing refers to taking several shots at different exposure settings. In-camera light meters do an excellent job automatically, but they can't "think." Occasionally, the in-camera meter will generate an exposure that ignores an element in the frame that's of special importance to you. By bracketing, you ensure that the critical subjects are properly exposed. In the film camera world, this was an expensive proposition, but with a digital camera, it's easy to bracket and discard the images that aren't right at no cost.

Your camera's light meter can be fooled by very dark, light, or reflective subjects and scenes with unusual lighting. Use exposure bracketing to ensure you get a properly exposed image.

Some cameras include an Auto Exposure Bracketing control; if yours does, you can set it to shoot three frames, varying the exposure by 0.3 or 0.5 steps. Otherwise, simply use the exposure compensation control marked [+/-] on most cameras. Take one shot without any setting; then set +0.5 and take a second shot; finally, take a third shot at a -0.5 setting. You can use larger increments of +1 and -1 if you find that 0.5 does not make enough of a difference in your images.

Archive Images Immediately

Workflow is important when you use a digital camera. If you don't develop good habits, you can easily lose images forever. I like to download my images from the memory card to a folder on my computer desktop. Then I do a quick batch rename (with an image-management program like ACDSee) on all of the images to get rid of the cryptic name from the camera. Typically, I don't even try to edit the pictures at this point.

Once they're renamed, I immediately burn all of the images to a CD or DVD. That becomes my fail-safe backup copy of the images. I only erase the memory card after I confirm that the images are safely saved on the CD or DVD. I adapted this workflow after losing a number of images to a computer crash—never again!

Frame Your Prints to Preserve Their Life

Inkjet prints are infamous for fading quickly. While ink and paper manufacturers continue to make great strides in improving the life expectancy of inkjet prints, it's a good idea to protect your favorite images from the elements.

Sunlight is one of the chief enemies of print longevity. Gasses in the environment also can be very detrimental to your prints. The best way to protect them is to mount and frame them under glass. Choose acid-free matte papers and mount your prints with "archival" tape. UV-reflective glass also is preferable to plain glass, but be sure to use some type of glass. Once framed, hang your prints away from direct sources of light. Protect your prints, and they will last much longer than if they are left unprotected.

Of course, one of the great benefits of digital photography is that you can always make another print easily in the comfort of home if a favorite image begins to fade or color-shift.

Composition and the Digital Advantage

Make use of instant feedback to refine your composition skills.

By Wes Pitts

What makes a good photograph? Good is a subjective quality, but there are basics that are generally agreed upon. Correct exposure and focus are important. Then there's the more abstract concept of composition. Simply put, composition is an arrangement of forms within the frame of the image. Artful photographic composition can express even a mundane subject in an exciting way. Good composition reflects your attention to detail.

With digital cameras and their real-time LCD feedback, practicing the art of composition can be more fruitful, more quickly. Compared to squinting through optical viewfinders, using the LCD to frame your shot gives you a much better idea of how your image will look before you take it. It's like looking at a miniature version of your final print. Plus, you can review your image right away and compare it to what you expected or wanted. If you're not satisfied, you can try the shot again right then and there.

Some aspects of photography haven't changed. The same rules and ideas of composition apply to digital photography just as they apply to film. Regardless of the recording medium, it's the final image that counts, and the art of composition is fundamental to what and how that final image is going to communicate.

Centering the painter in the frame creates a static image. By moving the painter into the right third of the frame, the viewer's eye travels across the photograph following the painter's gaze.

The Rule of Thirds

This is a common concept in photography and other visual arts. The idea is to divide your frame into three equal sections both horizontally and vertically—something like a tic-tac-toe board. The intersections of the imaginary dividing lines are considered to be ideal areas of the frame in which to place your subject because these are the places where the viewer's eye tends to rest.

Some people take the Rule of Thirds a bit too seriously perhaps, as it isn't a hard and fast "rule" as the name suggests. Instead, it's a good starting point for a pleasing off-center composition, helping to prevent the "bull's-eye" syndrome: placing your subject in the center of the frame. Your digital camera's LCD monitor makes visualizing the imaginary dividing lines and placing your subject a bit easier than when squinting through a viewfinder. A few digital cameras will actually superimpose the Rule of Thirds grid over your image as a menu option.

Points of a Circle

Think of your subject as the center of a circle, and you, the photographer, as every point of the circle around it. Move around that circle and watch as the scene changes on your LCD. Your subject is a part of its context, and as you view it from different points on the circle, the subject and its context change.

The intention here is to explore as many ways as possible of expressing your subject in its environment because your first approach to the subject may not make the most of its surroundings. Once you take a photo of your subject that you like, find an entirely new way of photographing the same subject. Some of the shots will be more successful than others, but the great advantage digital photography offers is that you can always delete the images that don't work.

Watch Your Edges

Many would-be terrific images are compromised by a stray element sneaking into the edges of the frame. Peering through a tiny optical viewfinder, you may miss a lone branch or half of someone's arm creeping into your image. Yes, you can always crop out unwanted elements later, but doing so means you'll lose some of your image's resolution.

Using your camera's LCD monitor to compose your photographs helps because you get a larger view and stray elements are more easily noticed. Optical viewfinders are nice to have when you need to save battery power or can't see the LCD screen in bright sunlight, but these viewfinders often fail to accurately show what the lens is actually "seeing." The LCD monitor, on the other hand, typically provides an accurate representation of what the camera will record.

Many digital cameras have flip-out, rotating LCD monitors, which make it much easier to try new angles because you can hold the camera up in the air or down by your knees and still see the LCD screen.

Get Close

Many photographs are taken too far from the subject. Maybe it's because cameras seem intrusive, so photographers naturally and unconsciously keep a distance from their subjects. However, the final photograph is going to be more interesting for the viewer if the subject is prominent in the frame. Taking just a few steps toward your subject may dramatically improve your composition. Try it and watch how the image changes on your LCD monitor.

Another way to get up close and personal with your subjects is to shoot macro: extreme close-ups of subjects a few inches from the lens. Digital cameras have opened up a whole new world of possibilities for many photographers because of their macro mode. Almost all digital cameras with built-in lenses have this mode. Film photographers have to buy a special lens to allow this, but digital photographers can try macro photography with the push of a button.

If a scene catches your eye, don't just snap one picture and walk away. Pick a detail out of the scene, then move in close for your photo.

A zoom lens is extremely handy. With the wide-angle setting you can take in the whole scene. Then use the telephoto setting to isolate interesting details.

Sublime Simplicity

The more concentrated and simple your photograph, the more visually appealing it's likely to be. With busy scenes where a lot is happening, it's hard to emphasize the geometry of the forms in the image. Simpler images will also tend to communicate better to your viewers, as there's less to figure out when seeing the image for the first time.

You can simplify your image by getting closer to your subject or using your digital camera's zoom lens at the telephoto end of its range. The latter has the additional benefit of diminished depth of field: a narrower range of sharpness. That can be useful to soften and blur objects in the background, making them less distracting. If your camera allows you to manually select your aperture, you can choose a wide aperture (largest f/number available) to limit your depth of field. Also use the longest zoom setting that is available.

What's Your Angle?

Too often, photographers approach their subjects from an eye-level point of view. By this, I mean they stand straight up and photograph everything from their natural height. This consistent approach can result consistently in a dull images.

Break out of this two-dimensional mold with a conscious effort to find another angle on your subject. Get up above it or kneel down and shoot up at it. Doing this lets you look at your subject from a new perspective; maybe you'll discover a more interesting relationship between your subject and its surroundings from a different angle.

Think of Your LCD Screen as a Print

If you're accustomed to film cameras, you may think of the viewfinder as a mere sighting device. Imagine that the image in your LCD screen is a final photograph, hanging framed on the wall. Are you satisfied with what you see?

Approaching your compositions in this way will help you to really see the whole, rather than the parts. It's easy to only "see" your subject when composing an image, which can cause you to ignore the subject's surroundings. Seeing the whole image in the LCD screen will help you better apply the other compositional ideas we've discussed here.

Selective Focus

Use this key photographic technique to distinguish your subject from its surroundings.

By Rob Sheppard

Selective focus helps isolate your subject from the background.

One of the challenges we face as photographers is making the subject stand out from its surroundings. An effective way to do this is to use the selective focus technique. This concept refers to choosing one part of the image to be sharp and in focus while rendering the rest (especially the background) as softly blurred: out of focus, as mentioned briefly in the previous article. It's the opposite of getting a lot of depth of field, a great range of apparent sharpness from foreground to background.

When using the techniques to be discussed, you'll make images that allow the viewer to know at a glance what's important in the photo; it's also a way to make interesting compositions that can't be duplicated any other way.

It's possible, and often useful, to create a selective focus effect in the computer by selecting one part of the photo, keeping it sharp and blurring the background or other image elements Shooting the image with selective focus from the start has advantages, however: You spend less time on your photo in the computer; your composition better fits the in- and out-of-focus areas; the effect always looks natural (because it is); edges are never a problem (the computer-generated effect can be difficult with edges); there's no problem with the "wrong" elements being sharp or blurred; and transitions always look right.

Selective focus is accomplished with the following steps:

1. **Choice of f/stop**—Choose your widest f/stop, the smallest f/number available with your camera or lens. Wide apertures minimize depth of field; only elements at the focused distance will be really sharp.

 When using very wide apertures on sunny days, shutter speeds will be extremely fast; in some cases, the camera will not have an adequately fast shutter speed to make a correct exposure. If that is a problem, select the lowest ISO setting available. In extremely bright light (especially with a compact camera without a wide range of shutter speeds) you also may need a neutral-density filter (a dark gray filter) or a polarizer to reduce the amount of light that will reach the sensor.

2. **Long focal lengths**—Use telephoto settings of your zoom or choose a telephoto lens. The stronger the telephoto, the more dramatic the selective focus result. That's because depth of field is shallow at high magnification causing the background to be very blurred while the focused subject stands out in bold relief. If your camera accepts a telephoto adapter, you may want to consider buying an accessory of that type.

3. **Angle to subject**—Having strongly contrasting sharp versus blurred areas of the photo makes this effect work its best. Often, this is done when you carefully choose your angle to the subject. Find the angle that keeps background or foreground elements farther from the focused subject. For example, go low to a close-up so the background seen by the lens is far away and, therefore, more likely to be completely out of focus.

4. **Focus on your subject**—Look for an element you can shoot through or against that can be strongly out of focus in such a way to contrast with your in-focus subject. Move around until you find a colorful foreground element: some tree branches, with foliage, for example. Focus on a more distant subject and the element framing the foreground will be softly blurred for a pleasing effect.

 Or look for a shooting position that lets you frame a nearby subject against a background that's very far away, particularly one with a complementary color. Even though the background will be blurred, that feature still can be important for color and shape elements in your composition.

5. **LCD review**—Check your composition in the LCD monitor to be sure the in- and out-of-focus areas successfully complement each other. Enlarge the image in the LCD screen in Playback mode so you can clearly see important details.

When using selective focus, the background can be in soft focus and still be recognizable.

JPEG is perfectly capable of outstanding image quality as seen by the photos in this article. It's a myth that RAW is the only format to use for high-quality images.

The Power of JPEG

Create outstanding photos with JPEG capture by following these shooting guidelines.

Text and Photography by Rob Sheppard

The two primary shooting formats for digital cameras are JPEG and RAW. JPEG is a file compression format that offers superb image quality when used correctly. The RAW format (raw data from the camera's sensor) is an excellent format for photographers who either need it or like working with it, but it isn't for everyone.

I largely shoot with JPEG and only shoot RAW when I need it for its greater tonal range or for dealing with problem situations. (Many image parameters can be adjusted in the special converter software before processing and conversion to TIFF format.) My images have appeared regularly on these pages and in my books, so obviously JPEG is a quality format. Newspaper photojournalists largely shoot JPEG, and so do many other pros.

Because JPEG is such an important file format, I thought it was time someone provided pointers on how any photographer can get the most from it. There's no question that following many of these tips will improve RAW capture as well.

Why Shoot JPEG Anyway?

Let's begin by acknowledging that RAW offers superb benefits of increased adjustability for image files, and some photographers simply like working with all the adjustment possibilities it features. RAW isn't the "pro" format and JPEG the "amateur" format. Once exposure is beyond the range of the sensor, RAW offers no benefits over JPEG. Whether shooting RAW or JPEG, it's always good technique to shoot it right from the start.

Adjusting a well-shot photo to make it look its best is always less work and more profitable than fixing a problem shot. As a compression format, JPEG takes a file and reduces its saved size by removing redundant data. It then rebuilds that file to its original size when opened in the computer. JPEG has a number of important advantages to the photographer that are well worth considering:

Size

This is the obvious benefit; generally, you'll get two to three times the number of images on a memory card by shooting high-quality JPEG compared to RAW.

Camera Speed

These smaller file sizes display faster on camera and computer, boost the number of shots that can be taken consecutively, and often increase the shooting speed of a camera.

Quality

Images photographed with JPEG settings take advantage of in-camera processing. On most digital cameras, this processing is quite remarkable, and will give you a file that's like a processed RAW file without any extra work. This processing takes the 12-bit sensor data (used by RAW, too) and smartly converts it to the 8-bit JPEG file with some remarkable algorithms. You get none of that with RAW although some of the RAW conversion software programs are quite sophisticated in their processing.

Workflow Speed

JPEG files transfer faster from memory card to computer, to start. Then when you work on them, you go directly to the image-processing program without having to use an intermediary RAW file converter (whether that's the manufacturer's, an independent brand or Adobe's converter

Three different exposures were made of this lamppost. The camera was mounted to a tripod, and only the file format changed.

Photo A is the highest-quality JPEG. Photo B is a RAW file converted directly to a working file. Photo C was shot with the camera's lowest-quality JPEG setting. You'll notice that none of these images is bad. Both JPEG and RAW can produce high-quality images.

in Photoshop). One qualification: Once you open a photo file in the computer, never resave it as a JPEG file. That will lead to lower quality. Save it as a TIFF or use the native file format of your image-processing software.

Disciplined Shooting

I firmly believe that you get the best photos by paying attention to detail as you shoot and not by hoping to fix it in the computer later, as some photographers advocate. JPEG doesn't have the "fudge factor" of RAW. While you can "fix" a lot in the computer, extreme adjustments don't sit well with JPEG.

Shooting in JPEG focuses you on getting the best shot from the start. This goes beyond simply dealing with a requirement of the format (JPEG is technically a compression scheme and not a format, but its usage in digital cameras is as a format, so we follow that convention). When a photographer focuses on getting the most from every shot, he or she will check all the details—which often are missed by sloppier work that can be "fixed in the computer." Even an experienced RAW master can't make an incomplete RAW file match a well-executed JPEG image.

Getting the photo right in the first place is important for another reason—less time in front of the computer until I have an image I like. This is an essential workflow issue for me. Photos that aren't quite right can take too much time to correct.

Use High-Quality Settings

Choose high-quality settings for JPEG. Most cameras include several JPEG options from high to low quality. The low quality option produces a file with aggressive compression, which makes for very small files, but this throws out a lot of data. That loss of data can result in significant quality problems. JPEG can offer you

detail that will match any RAW file, but only if you choose the highest quality setting, often called Super Fine or Fine or Best, depending on the camera. These will give you slightly larger file sizes, resulting in fewer photos on a memory card, but still far more than in RAW format capture

Also be sure to select the largest JPEG option (most pixels) to take full advantage of all the resolution that your camera offers. After all, this is what you purchased with your camera, so why not take advantage of it!

Exposure and Light

Keep this in mind: JPEG's 8-bit files have the most difficult challenge keeping up with RAW in the darkest and lightest tones of a photo. Pay attention to how your exposure is reacting to the dark and light areas of the scene. This can be a critical lighting issue, so be sure important details have the light they need.

You'll need to make some decisions. If the brightest parts of a scene are critical, expose so that detail is retained. If the darkest shadows are most important, make sure your exposure captures that detail properly. Dark area exposures have a big effect on both JPEG and RAW files because significant underexposure will increase the appearance of noise in those areas.

Many digital cameras have an overexposure warning—bright areas blink on the LCD monitor in Playback mode—to indicate a loss of detail in those areas. That feature can be helpful in seeing problems with bright areas. However, the way to be certain of your exposure in important parts of your composition is be sure to read the next article on the histogram.

White Balance

I rarely use Auto White Balance for three basic reasons: it doesn't consistently give me the best colors (either from an accurate or creative point of view); it gives inconsistent results when shooting multiple images in a scene where you change your angle to the subject and lens focal length; and it's usually based on a smaller color temperature range than the camera is capable of handling. Auto white balance's inconsistency is due to the camera's attempt to adjust to the different things it sees on the sensor, which leads to definite workflow challenges in trying to match photos later.

I recommend shooting with presets that work for your scene, such as daylight for daytime shooting, incandescent for indoor work, cloudy for shade and overcast days (plus for sunrise and sunset), fluorescent for those lights, and so forth. Experiment to see what you like best; I often use the flash setting for daylight exposures.

Learn to use your camera's custom white balance feature as well. This is the best way to get accurate, brilliant colors from every situation. Most cameras deal with a greater range of color information from a scene with this setting than is possible with auto white balance. Custom settings are based on the camera measuring the color of light as it's seen on a white or gray card.

The white balance preset for cloudy or shady lighting can be used to maintain the warm light of a sunset.

Sharpness

If we're discussing optimum quality with JPEG, we need to talk sharpness. The number-one cause of a photo's lack of sharpness isn't poorly designed lenses, but camera movement or shake during exposure. This does more than make a photo look blurry; at minimal levels of shake, the photo might not even look too bad, but image brilliance and crispness will suffer, dulling the shot.

Hold the camera as firmly, yet comfortably as you can. That means no flying elbows, no light-fingered grips and no one-handed shooting. Press the shutter firmly, but never punch the button.

Be aware of your shutter speed. When the camera is shooting automatically, this is easy to overlook. Be wary of shooting anything under 1/60 second, and if you're using a telephoto focal length, that shutter speed needs to get much faster (1/500 second perhaps) to maintain sharpness.

When your speeds drop, look for ways to stabilize your camera. Image-stabilization technologies can help you get sharper images at slower shutter speeds. In a pinch, you also can brace your camera against a solid object.

JPEG + RAW

Many digital SLR's offer the ability to shoot both RAW and JPEG at the same time. This gives you the advantages of both (but you still need to set the JPEG for its highest quality if you want it to offer a comparable file to RAW). The disadvantage is that you use up a lot more storage space, and you'll fill your memory cards faster. Plus, there's a change in workflow needed to deal with the additional files.

The Magic of Histograms

Learn to read your camera's histograms and get the best exposure possible for your subject.

Text and Photography by Rob Sheppard

Modern digital cameras do an impressive job in getting an acceptable exposure for most images. There's a difference between an acceptable exposure and an exceptional exposure, however. The best exposures make maximum use of the capabilities of the camera sensor and internal camera processing.

While it's true that image-processing programs do allow some "fixing" of a photo in the computer, you're wise to get the best possible image captured to the memory card in the first place. This results in an image with clearer details, better tonal definition in highlights and shadows, improved color, and fewer noise issues.

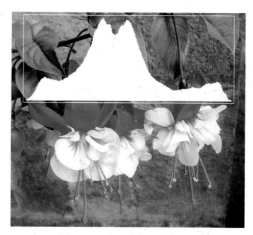

Many digital cameras can display a histogram to help you make informed exposure adjustments.

Arch, Chinchero, Peru
This photo has a good range of tones, as seen in the histogram. The critical area for exposure in this shot is the sunlit white part of the arch. This easily can be overexposed, which would wash out its detail and texture. The dark sky and shadow in the center of the frame could influence certain cameras to give too much exposure, which would wash out the bright whites. The histogram tells it all. The graph slopes down at the right before hitting the edge, which means all the bright tones are captured correctly. That's key—if the highlights are clipped because the values extend beyond the graph's edge, then the exposure will blow out all of their detail.

There's a serious misconception that with RAW capture, shooting the image properly from the start is no longer important. Not true! The image sensor is only capable of handling a certain range of brightness. Outside of that range, you have problems. RAW files can help with challenging exposures, but even that format works best when the exposures also are at their best.

One way to ensure that your exposures are accurate is to use the histogram display, if your camera has one. More and more cameras are including this valuable technology, including some compact models selling for less than $400. You don't need to use it for every image, but if you check it when the light is tricky and for critical photos, the histogram can give you important information about an image's exposure.

The histogram sometimes looks a little intimidating. It was never part of film photography, and it certainly doesn't look very creative. It's a graph based on mathematics, but to use it, you don't have to know anything about math. This article will give you an overview of what to look for in your histogram and offer some specific photographic examples showing both an image and its histogram.

Histogram Basics

While the histogram looks rather technical at first, the basics of reading it are fairly simple. Camera manufacturers haven't always made finding the feature in the menus that easy, so check your camera's manual to see how to turn it on, if your model includes it.

With digital SLR's and many digital cameras, you have to look at the histogram after you take the shot. With some digital cameras, you can turn on the histogram for live viewing as you prepare to take the picture, which can be helpful in adjusting exposure on the fly.

The histogram is a chart that looks like a hill or mountain range, but the key elements are the slopes at the left and right. Some histograms are solid graphs, while some just show a line where the tops of the points are—both are identical in use, they are just different displays.

To read exposure, begin by looking at the left and right parts of the chart. The left shows the darkest parts of the scene and the right displays the highlights. The entire width of the graph represents the total range of tones that your sensor can capture. Anything beyond the left edge is pure black, outside of the range of the sensor, so nothing is recorded in those shadows. Anything beyond the right edge is pure white: outside of the range of the sensor and containing no visible detail.

An image with satisfactory exposure will have a full range of tones from left to right appropriate to the scene. There's no "correct" shape to a histogram, since that will change depending on the types of tonalities in your scene. The key, though, is to be sure no exposure information is clipped at the right or left (the graph is abruptly cut off), which represents the exposure level where detail is gone. A cutoff or clipped histogram means details aren't being captured at all.

That's not necessarily wrong, however. Some scenes simply have too great a contrast range for your sensor, which will result in clipping at either the left side (shadow), the right side (highlight) or on both sides. This is most likely with scenes with extremely bright areas as well as extremely dark areas; it's impossible for your camera to record detail in all areas.

Church, Cuzco, Peru
There are several dark areas in this image that might have over-influenced the meter, causing the camera to give the scene too much exposure. That would have caused problems in the small white statue and the window. The exposure here is correct—no highlights are clipped in the histogram. Much of the graph is in the middle and left side, which is okay, since most of the tones in the subject are middle-toned or darker. A little bit of dark shadow is clipped at the left side, but that doesn't hurt anything. In this particular photo, losing detail in the dark shadows isn't a big deal and even makes the image look more dramatic. Having the statue overexposed would be much more of an issue.

In any high contrast situation, you may have to decide what's most important for your scene—highlights or shadows—and be sure the histogram isn't clipped at either end. Bright specular highlights from glaring lights probably should be pure white, for example. A deep shadow might look fine as pure black.

If an image is underexposed, the graph will have little or no data on the right side of the chart; most of the data will be skewed to the left. Often, the hill at the left will be cut off sharply at the far left edge. Underexposure can cause two major problems. The first is obvious—less detail in the shadows. The second appears when you try to adjust the image in the computer—noise. Underexposed, dark areas often will pick up annoying and distracting noise as you lighten them. The correction is fairly easy: re-shoot the scene after increasing exposure. If you're on automatic mode, use the + (plus) setting of the camera's exposure compensation control to bump up exposure.

An overexposed image demonstrates the opposite. You'll find little or no data on the left side of the chart compared with the right, and the right side often will be cut off sharply. That cutoff is a real concern, since the areas of exposure beyond that level (brighter areas) will be washed out, appearing blank in the photograph. The correction: re-shoot with less exposure. If you're on automatic mode, use the – (minus) setting of exposure compensation to lower exposure.

A photo of a low-contrast scene—without bright highlight areas or dark shadow areas—shows something entirely different. Typically, it will show a histogram with an entire hill of data well within the left and right borders. No tonal values will be seen near either the left or right side. This can be a challenging histogram because often it will need to be stretched in your image-processing program. That stretching (with the Levels function for example) can cause problems with tonalities banding because not enough data may be present to support all the tones.

Some low-contrast scenes should be kept low contrast, such as a fishing village in mist on a foggy day. Other scenes need correction, however. This is a good scenario for RAW capture, since it will allow stretching of tones without damage to the image. On many cameras, you can choose different contrast settings, from low to high. You may also be able to set a custom parameter on your camera just for cloudy days with flat lighting; that increases contrast, and saturation for a more pleasing, snappier effect.

Overall, you want your photo to display a histogram that slopes down as close as possible to the important brightness values of your photograph. If the highlights are critical, then the slope must end at or before the right side. If the shadows are essential, then the slope must favor the left side. This can be crucial in getting an image with proper data into the computer.

There are several ways of making these adjustments. The easiest way to deal with a scene is to become very familiar with your camera's exposure compensation control. Dial it down (minus, for less exposure) when the histogram is bumping the right side of its area; dial it up (plus, for more exposure) when the histogram is too far to the left.

Remember: There are no absolute rules for using a histogram. Every scene is different. You'll need to interpret the histogram as it relates to the scene in front of you and what you believe is a good way of seeing the scene. It's worth experimenting—with digital there's no cost for taking extra shots. Try different exposures and see what they look like on the histogram to learn how this function reads various scenes.

Night Square, Cuzco, Peru

Two versions of this night scene in Cuzco were taken and they show similar histograms. If you look closely at the two histograms, you'll notice the data in the good exposure is expanded, compared to the underexposed version. There's obviously a lot of dark (and even black) tonality in a night shot, so both have most of the graph data at the left side. However, examine the graphs carefully, and you'll see certain hills (especially the last peak before the graph heads steadily to the right) that are the same, but in different places on the graph. The data is all crammed into the left side in the underexposed image, which means that while it can be expanded in the computer, there will be difficulties with tonalities, color and noise. Noise especially is a problem. It's true that some bright lights are clipping at the right side of the good exposure, but that's normal for this type of night shot and should be allowed.

Good exposure　　　　　**Underexposure**

These two details are from two different night square exposures. The tonalities look much more refined and smooth in the good exposure (left). The underexposed image (right) has a lot of noise that isn't in the good exposure.

Creating a Better Portrait

Understand how simple techniques will aid you in producing professional-quality portraits.

Text and Photography by Ibarionex R. Perello

I love photographing people. Since the first moment I picked up a camera, people were the subjects I sought to capture on film. For a shy, young kid, I found the camera to be a great tool for communicating with another human being. It's still exciting to create a portrait over which both my subject and I are thrilled.

Admittedly, I still get the butterflies when I want to create a portrait. Yet, I've found that there are certain steps I can take to help ensure I get good results. I want the time spent creating a portrait to be enjoyable and gratifying, and to have that reflected in the final print.

So, here are some suggestions that, whether you're behind the camera or in front of the computer, will help you create better portraits.

Soft, even lighting provides a flattering look to portraits as in this image of a young woman. Avoid harsh lighting conditions and choose more favorable illumination for better photographs.

Choosing the Right Focal Length

The intent is to create a photograph that brings full attention to the subject. One way to do this is to choose a focal length that will isolate the subject from the background. While a wide-angle lens will encompass the subject and also the surrounding environment, a telephoto focal length will isolate the subject from his or her surroundings due to its shallower depth of field. It will also produce more pleasing perspective, particularly in a head-and-shoulders shot.

As some digital cameras don't have clearly marked focal lengths, I zoom the lens out to its maximum focal length. On many of today's compact cameras, this is approximately 105–120mm (35 equivalent). If you're still unsure, I suggest standing about 10 to 12 feet from your subject and adjusting the zoom lens until you can frame just your subject's head and shoulders.

Keep the Background Simple

Sometimes in my excitement to create a photograph, I forget to pay enough attention to the background. A great shot can be ruined by a distracting element such as a tree or a car. So, I make it a point to look for a good background. It can be as simple as a wall or shrubbery. Whatever it is, I try to find something uniform in color and texture. I'll also pose my subject in front of a passageway that's heavily shadowed, such as a doorframe. The darkness behind the subject serves as a natural backdrop that immediately draws attention to the subject's face.

Looking for the Light

Although we all know light is needed to create a photograph, it's the search for the special kind of light that will elevate an image from a snapshot to a photograph. I avoid direct sunlight for the simple reason that it's far too contrasty. It creates unflattering harsh shadows beneath the nose and it makes people squint.

Instead, I'll move my subject into open shade where the light is soft and even. An overcast day provides the perfect portrait light. On such days, the clouds can serve as a massive lightbox, producing soft, near-perfect light. However, make sure to watch for shadows on the face. And remember, whether it's the light or the background, don't be afraid to ask your subject to move to a different location, especially if it will result in a better photograph.

Keep the background simple and look for good light. Although the image was shot at noon, the open shade produced by the wall provided flattering light for a portrait. Luckily, the wall made a great background as well.

Turn on the Flash

Even when I'm outdoors, I'll consistently use my camera's built-in flash. The mode is accessed by pressing the flash control button until a symbol of a single lightning bolt appears on the LCD screen. It's a great tool for providing illumination for a backlit subject. On overcast days, it can also add a little punch to a portrait by bringing out colors in the subject's clothing, skin, and eyes. The flash, instead of overpowering the existing light, actually complements it. It also eliminates any undesirable shadows and produces a nice catchlight in the eyes.

Keep Your Camera at Eye-Level

Avoid positioning the camera below or above your subject. I'll normally position my camera at eye-level or just slightly above it. If my subject is sitting on the ground, I will sit down with him or her.

Don't look down on your subject. Standing over your subject will result in a bad portrait and will likely make your subject very uncomfortable.

Warming Skin Tones

Look at any fashion magazine and you'll notice that a large percentage of the images appear to have been shot late in the day. This is because the late-afternoon light produces a warm colorcast that's particularly flattering. The look is so appealing that many photographers will use a warming filter to produce a similar look, even if they're not shooting during that time of day. With a digital camera, you can get a nice warm effect by using the Cloudy Day white balance setting in sunny conditions.

You can also achieve a warming effect in a computer, using the Color Balance or similar tool in image editing software. By slightly increasing the amount of red and yellow, you can simulate late-afternoon light. The software approach provides much greater control over this effect, especially if you use the Levels control and adjust the red and blue channels. Play with these adjustments until you get the appearance you're looking for.

Although the subject was in a shaded area, I recognized that the photo could benefit from a little flash. It revealed the details in his face and brought out the color of his costume.

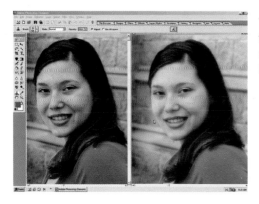

To improve this portrait of a young woman, I adjusted the brightness and contrast, retouched the blemishes on her skin, and then, softened the image with Gaussian blur.

Removing Blemishes

Since your portrait will be dominated by the person's face, acne or other skin blemishes can become exaggerated and detract from the appeal of the portrait. An easy means of removing such defects is through the use of the Cloning tool or Healing Brush tool available in image processing software.

Select another part of the person's face that's free of the flaw, but whose tone and color matches the area that you wish to replace. Make sure that your cloning tool has a soft edge so that the application of the tool appears natural and seamless. Rather than moving the cloning tool continuously around an affected area, click on specific spots. This will help in producing an almost undetectable adjustment of the image.

Lightening the Eyes

Since the eyes are the most important part of any portrait, many professional photographers use a fill light to bring out the color of the eyes. Even if your original image didn't have the advantage of such a light, you can still bring out details in the eye in a variety of ways.

Try brightening the dark area around the eye by using the dodging tool in imaging software. Select shadows for range, and

make sure to reduce the sensitivity of the tool so that the effect doesn't appear exaggerated. I suggest trying a sensitivity of 5–10%. You can also select the area, making sure to feather or smooth the edge. Then, by using the Levels control, increase the brightness of the midtones. Not only will the colors be brought out more, but the eyes will derive a greater impact from the adjustment as well.

Softening the Face

When it comes to reducing the impact of wrinkles, photographers often use a soft-focus filter. Attached to a camera lens, it slightly diffuses the light and softens the appearance of the skin. However, unlike a filter, a computer provides much greater control of the amount of softening you can apply to the portrait.

You can create the effect under a Blur or Filter option in your software, but in either case, the effect is easy to control. A quick and simple way is to apply a light Gaussian blur (1 to 3 setting) to the subject's face. But if you want more control, create a duplicate layer of the image and apply a moderate degree of Gaussian blur. Then, adjust the opacity control for the new layer until you get the look you like, as it will be a very subjective choice.

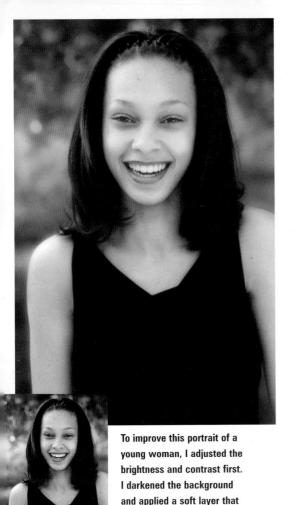

Darkening the background is an effective means of bringing attention to your subject. After creating a duplicate layer of the original image, I selected the Difference option and adjusted the opacity to approximately 33%. I used the eraser tool on the subject area on the top layer, maintaining the darker layer on the background.

To improve this portrait of a young woman, I adjusted the brightness and contrast first. I darkened the background and applied a soft layer that smoothed out her skin tone.

After creating a duplicate layer of my original image, I applied a heavy Gaussian blur. I adjusted the opacity of the layer to approximately 35%, resulting in a pleasing portrait of the subject.

Burning in the Background

I worked for a while at newspapers, and one of the techniques often used to bring attention to the subject was to burn or darken around the subject. As our eyes are always drawn to the brightest part of the image, the viewer's eyes would focus on the subject. You can achieve this effect in the computer by selecting around your subject, inverting the selection and again making sure that you feather the edge. Then, by either using the Brightness or Levels control, darken the background.

I personally prefer creating a duplicate layer of the original image, and selecting the Difference option for it. I adjust the opacity setting to approximately 20%. You'll see that the entire image will appear darker. I then apply the Eraser tool to my subject area on the top layer, avoiding the background. The subject will appear brighter and will have more impact in the final print.

Reflectors for Digital Work

Simple-to-use reflectors and diffusers can help you make the most of any lighting situation.

Text and Photography by Ibarionex R. Perello

To create a great portrait with my digital camera, I need to control light. To make a portrait that my subject and I are going to be excited about, I must work with light like a sculptor works with clay— I'm going to have to shape it and control it. While flash can be useful, reflectors and diffusers offer much greater control and versatility.

While photographing a friend's twins in the comfort of their backyard, I had to contend with harsh afternoon light. Normally, I'd pull them into the shade, but the resulting shots are often flat: without contrast or modeling. Instead, I found it a perfect opportunity to use reflectors and diffusers to create dynamic lighting that elevated the photographs from mere snapshots to nice portraits.

Diffusers and reflectors provide an easy and affordable means for controlling light. Rather than accepting or avoiding a bad lighting situation, these tools let me use it to my advantage.

First, I set up a diffuser between my light source (the sun) and my subjects (two inexhaustible twins). Made of a translucent material, the diffuser softened the late-afternoon light and created even illumination over the children. The diffuser reduced the sharp contrast of the original scene and eliminated the problem of the children squinting into the sun.

Next, I positioned a white reflector to the left of my subjects. When properly positioned, reflectors catch light and redirect it. In this case, I used the light to brighten

Using a diffuser created soft and even illumination. A reflector positioned to the boy's lower left filled in shadows and brightened up the scene.

up the scene and eliminate shadows beneath the twins' brows, noses and chins. It also succeeded in bringing out the color of the children's eyes.

If I had wanted to warm up the scene, I could have used the gold reflective surface of the reflector. This would have produced a warm tone often found in fashion spreads in women's magazines. I only do this on overcast days or when sunlight is softened by a diffuser, as the gold reflector can sometimes reflect harsh light into the subject's eyes and make them squint.

Usually, I'll have a friend hold the reflectors in place while I'm photographing. They can easily confirm that they're holding it correctly because they'll see the light from the reflector hitting the subject.

If someone isn't available, I'll use light stands and a boom arm. After positioning the diffusers and reflectors, I'm free to direct all my attention on my subject. If working under windy conditions, I'll use small sandbags to hold the light stands in place (a heavy camera bag will do in a pinch).

Although I could achieve similar effects with a white matte board, today's reflectors and diffusers are collapsible and extremely portable. I can set up and strike down in less than 10 minutes. The less time I spend setting up, the more time I have with my subjects so I can help them become comfortable. The informal quality of the setup also helps to relax them and allows me to capture more natural expressions.

Above: Harsh sunlight produces a high-contrast scene and causes the subject to squint, resulting in a less than satisfactory portrait.

Left: The final image shows how the diffuser and reflector deliver bright and even illumination perfectly suited for portraiture.

Digital Camera Close-Ups

Five tips that will help you capture great close-up images with your camera.

Text and Photography by
Rob Sheppard

Step beyond the normal range of human attention and enter the world of the close-up, little seen even by most photographers (according to research done by Kodak). Close-up and macro photography are sure ways to gain impact with your photos and get your work noticed—they aren't the usual photographs.

The great news about almost all non-interchangeable lens digital cameras on the market is that they allow you to focus at close-up settings without any extra gear. If you haven't used the button or setting with the little flower icon yet, give it a try. You may be surprised to find out how close you can get.

Once you start exploring the close-up realm, which can range from photographing interesting bugs in the garden to heirloom jewelry, you'll find whole new possibilities for your camera.

Use Your LCD

You see what the lens sees when you use the LCD. Often, you can view the LCD screen from a slight distance (especially with tilting LCD models), so you don't have to have your head right in the middle of everything you're photographing.

Focus Carefully

Focus is critical with close-ups. Often, compact cameras have trouble finding the right point on which to focus when you get up close. Try moving the camera around slightly until it focuses where you want. On most cameras, you can lock focus by depressing the shutter release halfway and then reframe your shot to the best composition.

Some advanced compact digital cameras and all digital SLR's let you focus manually. I like to set focus as close as possible, then move the camera back and forth until the subject is in focus. This can be an easy, reliable technique for consistent close-up focusing.

Close-Up Lenses

Since most cameras have Macro settings for close focusing, why would you need an accessory close-up lens? Flexibility. Most digital cameras will focus close, but with definite limitations on zooming. Often, macro focusing is only available at a fairly wide angle zoom setting. With a quality achromatic accessory close-up lens like those from Canon, Century Optics, Nikon, or Olympus, you can shoot very close with more focal length choices.

If your subject has a lot of detail, set it off against a soft background.

I like being able to get very close with a telephoto setting for its perspective and selective focus effects.

Watch the Background

A sharp, dramatic close-up subject can be lost if the background fights with it. Look to make your close-up backgrounds simple and complementary to the subject. It's easy to miss them because the close view of the subject can be so affecting as you take the photo.

Try keeping the background out of focus by using a wide lens opening (smaller number aperture), by zooming to telephoto focal lengths and by finding an angle that keeps the background at a distance from your subject. You can also look for a background that contrasts with the subject in terms of light/dark contrast or broad expanses of color.

Flash

Close-up flash used to be a real challenge if you didn't do it all the time. Modern flash units make a good exposure easier to get, but it's difficult to judge how the flash angle or contrast looks in the final shot. There's the benefit of a digital camera—you can check your shot immediately after exposure to see if the flash did what you wanted it to do. Then, you can make adjustments and try again.

If your camera accepts an accessory flash, use off-camera flash. This technique is discussed in the chapter "Better Flash Photography." If you must use on-camera flash, extreme close up shots may be too bright because of excessive flash output. If your camera or flash unit includes a Flash Exposure Compensation feature, try setting that to a -1 or -2 level to reduce flash intensity.

A Personal Macro Studio

Create professional-quality product shots using an easy and affordable setup.

By Ibarionex R. Perello

Nothing sells a product like a picture. Whether you're selling a collectible on eBay or advertising products offered by your small business, a good photo can attract a potential customer. In the previous article, Rob Sheppard provided some basic tips for making tight close-up shots of small objects. Those are certainly useful, but you may be able to make even better images if you're willing to experiment with some advanced techniques.

Tripod and Platforms

In order to keep the entire subject within the depth of field (range of sharp focus) use a small aperture: the largest f/number available on your camera or lens. When you select a small aperture, the camera will need to set a long shutter speed for a correct exposure at the low ISO settings that produce the best image quality. That will mean that you'll probably need to use a tripod to prevent blur from camera shake. A tripod promises stability to ensure a sharp photograph.

If you're shooting extremely small objects like rings or pendants, a small tabletop tripod is sufficient. However, make sure your camera is easily inverted vertically as well as horizontally. This provides greater flexibility for composition. Before purchasing, attach your camera to the tripod and test how the tripod works with your camera. If the camera is too heavy for the mini-tripod, the head may slowly creep out of position and make framing difficult.

In that case, go with a slightly larger and steadier tripod. Otherwise, a standard-sized tripod is sufficient.

Investing in a copy stand is ideal if you intend to photograph flat objects like photographs, magazines or stamps. (Look for a used stand at a large camera store that sells used products.) A copy stand is built around a flat baseboard where the object is placed. The camera is mounted above the baseboard on a center column. The camera then can be lowered or raised to achieve lesser or greater magnification.

A tabletop tripod is a stable platform for creating sharp images of small objects.

Lighting supports for either strobes or constant light sources are located on the opposing sides of the baseboards. These extension arms allow you to vary the position of the light to control contrast and reduce glare.

The column assembly on which the camera moves up and down is also very important. Designed around tension screws, roller bearings or a geared mechanism, the center column should allow precise positioning of the camera over your subject. Roller bearings or geared mechanisms offer the best precision and stability.

Lighting

Lighting has the greatest impact on your images. If your lighting is poor, the quality of your camera, tripod and filters make no difference. Professionals spend hours working a lighting setup to ensure the appearance of the product. Although you don't have to dedicate hours to getting the lighting absolutely perfect, having an understanding of lighting and an object's reaction to it are important.

As a source of illumination, the first and most obvious choice is daylight. When working with daylight, it's important to set your camera's white balance to the appropriate setting. Although automatic white balance may give you good results, I suggest that you set the white balance manually. You may even want to set a custom white balance to ensure color accuracy.

While you don't have as much control over the sun as you have with an artificial light source, you still have the ability to manipulate light by the use of scrims and reflectors. Scrims are neutral translucent materials that soften and diffuse light, reducing the harsh lighting produced by direct sunlight. Reflectors reduce harshness and contrast, as well as diffuse and reflect light on your subject. Available in varying sizes, these affordable devices offer control over sunlight and its impact on your small subject as they do in portrait photography.

A lighting cocoon diffuses ambient or artificial light, creating soft, flattering illumination for almost any subject. You can insert the object within the cocoon, which offers portals through which you can insert the

Collectibles like this Kodak camera jump out at the viewer (and would-be buyer) when you use a home studio to get the light and background just right.

A reflector lets you fill in shadows and control contrast when photographing small objects.

camera lens. Different lighting effects are created by changing the position of the light source. This is very suitable for objects that are susceptible to glare.

Your camera's built-in flash may be convenient, but it doesn't offer the best lighting for most objects and often produces a harsh, unflattering light. While good for merely documenting an object, it's particularly problematic when shooting highly reflective objects. However, flash can be used effectively for close-up work. Cameras that allow the use of supplementary wired or wireless flash provide greater flexibility for achieving lighting effects. By using more than one flash, you create a sense of depth, revealing texture and details in your subject. Although it involves a bit of experimentation, it can deliver superior results.

I've found that constant light sources, such as quartz, fluorescent, and halogen bulbs, provide one of the best ways to light close-up objects when shooting with a digital camera. These lights are available individually or in complete kits and are typically more affordable than a studio strobe system. Unlike flash units, these lights don't require the shutter to be depressed to supply their illumination. Since they're on constantly, you can evaluate the effects of the lighting with your naked eye and make adjustments on the

spot. The majority of these lights produce a lot of heat, so be careful with objects that are susceptible to their intensity.

Shooting Techniques

Since you want to bring attention to your subject, you need to eliminate distracting elements; plan to photograph your subjects against a uniform background. A black or neutral-colored sheet (or a piece of fabric) works well as a backdrop. Just make sure that the material is non-reflective to avoid glare or exposure problems.

Experiment with lighting. Try your first image with only one light, and then introduce a second light or a reflector. Position the light overhead or even slightly behind the subject. Try these changes and jot down notes about their positions. Once done, pull up the images on your computer. Despite the advantages of the camera's LCD monitor, the enlarged image on a computer screen allows you to better evaluate the image.

To improve the quality of your images, pick up a magazine that prints images of the types of products you intend to photograph. When I've attempted to re-create these shots with my setup, I've learned a lot about lighting and have improved the quality of my images.

Shooting Blurs

Use your digital camera to capture the power of motion.

By Ibarionex R. Perello

There's power in movement. A sharp action image can be dramatic and beautiful, but a blurred photo can be equally stunning when it captures the energy of a moment. Blur softens the details of an image and, although normally we try to avoid this when creating a shot, it becomes an invaluable tool when interpreting movement.

Where fast shutter speeds freeze action and produce sharp edges and contrast, a slow shutter speed smoothes and softens details. This technique is useful for simulating motion in a still image. Instead of emphasizing the peak moment, an image made with a slow shutter speed depicts the energy, form, and tone of motion.

Achieving good results with blur has always been a challenge. You either needed to have a lot of past experience or you had to be prepared to waste a lot of film. Now with a digital camera, the immediate feedback of the camera's LCD monitor lets photographers know whether they got the shot.

Digital Advantages

A digital camera's LCD monitor is a boon to photographers who want to capture movement using the motion blur technique. Simply set a slow shutter speed, focus on your subject, squeeze the shutter and within seconds you can view the

results on the screen. If the shutter speed was too fast or too slow, it only takes a moment to make an adjustment and try again. Gone are those days of waiting anxiously for film to be processed to determine whether you were successful.

Start off by setting your camera for the shutter-priority (TV for time value) mode. Select a slow shutter speed: 1/4 to 1/15 second is a good place to start. Then take a series of images at faster and slower shutter speeds and play back the images on the LCD monitor. You can quickly determine which setting will give the best results.

You may even want to experiment with the different look that various shutter speeds provide. In shutter-priority mode, the camera will deliver an accurate exposure by setting an appropriate aperture after you set the shutter speed; if the exposure is not quite right, you'll know right away when viewing the image on the LCD monitor.

Panning

Moving the camera with the subject, or panning, is an important technique when creating blur. The result is an image where the subject is relatively sharply defined while the background is significantly blurred.

The technique works well with moving subjects crossing your line of vision. Follow the subject's progress with your camera; at some point, depress the shutter release button to make an exposure. The key factor here is to continue moving the camera even after the shutter has been released. Abruptly stopping the motion of the camera will only make your entire image blurry and won't allow the subject to stand out from the background.

Cameras or lenses with a built-in "stabilizer" or "anti-shake" device enable you to make sharper images while capturing action. Such camera-shake-compensation systems shift lens elements, or the CCD sensor, to produce sharper images when you hand-hold the camera at relatively slow shutter speeds. Many of the latest Canon IS (Image Stabilizer), Nikon VR (Vibration Reduction) and Sigma OS (Optical Stabilizer) lenses also include a mode that optimizes the lenses for panning. When that panning option is engaged, the system compensates only for up/down camera shake for a smooth pan; it does not try to correct your intentional horizontal movement.

Above left: A fast-moving race car requires a shutter speed of no less than 1/250 second to maintain sharpness, while panning blurs the background.

Below left: The power of a sprinter is captured by using a very slow shutter speed (1/8 second). By panning on the main runner, the background is rendered as a streaking blur. The bright colors of his uniform and the track add vibrance to the image.

Flash Blur

For a trendy blur effect, try using flash while making an image with a slow shutter speed. This technique brings more definition to your subject while complementing the effect created by the blur. The majority of the image will be blurred, but a portion of the subject will be frozen by the brief burst of light from the flash, producing an interesting dynamic effect. Many digital cameras even include a Program mode or a "slow sync" mode intended for use with this technique.

By holding a beat after depressing the shutter release and then moving the camera slightly, a slow shutter speed can maintain detail in the buildings while including a dynamic blur to the scene.

selecting and using imaging software

One of the most significant aspects of digital imaging is the ability to modify images extensively. Given the right software expertise, and creativity, virtually any effect can be achieved in the desktop darkroom. Although some image adjustment options were available in the wet darkroom—particularly for black-and-white photos—imaging software makes the process much easier, as the scope of image adjustment and correction possibilities has expanded dramatically.

Instead of enlargers, harsh chemicals, and various types of paper, image-processing software is the primary tool in the electronic darkroom. There are numerous brands and versions of software for this purpose. Add-on software packages, called plug-ins, are also useful for adding extra capabilities or for automating complex processes. In this chapter, we'll review some of the most popular options in software and provide some techniques for solving common technical problems in the digital darkroom.

Recipes for Delicious Photos

Use your ingredients and these software techniques for tasty photographic results.

Text and Photography by Rob Sheppard and Wes G. Pitts

Making good photographs is a lot like baking a cake. First, you've got to choose the right ingredients. What you put in your photographs is as important as what you leave out. Imagine a cake with eggs, but also eggshells—yuck! You also need to know how to use your tools. It's not enough just to be able to turn on the oven. You need to set the oven to the right temperature.

So, when you go to bake a cake, you start with a recipe. The same goes for improving your photographs. We've compiled some of our favorite recipes for better images, from beginner's tips to advanced techniques, that we think every photographer will want to know.

We used different software for each tip, but with a bit of experimentation, you can probably get the same results with your photo-processing program. From fixing simple things like red-eye to increasing your image's color with digital paintbrushes, there's a trick in here for everyone.

Red-Eye Correction

Most cameras have a red-eye reduction flash mode, but from time to time you may still get images of family and friends who look like they're in dire need of an exorcism. Here's a simple technique for eliminating the red-eye phenomenon without calling your spiritual practitioner. (If your imaging software includes an automated red-eye correction tool, you may wish to use that instead.)

1. Select the red areas of the eye with the most convenient selection tool. We used Photoshop's magic wand, adjusting the tool's tolerance until we got an accurate selection.

2. Next, use the brightness and contrast controls to dial back the brightness until your subject's pupils are black.

3. Remove the selection.

If you forgot to set the flash to red-eye reduction mode, it's quick and easy to remove red-eye using image-processing software .

There were some stray feet in the background of this photo that needed to be removed. Areas of the grass surrounding the unwanted elements were selected to cover them.

Repairing Large Sections of an Image

The cloning tool in your photo-processing software is ideal for cleaning up and removing small, unwanted elements in areas of your image. For larger objects, though, it's often easier (and more effective) to copy and paste a larger selection of your image onto the trouble spot.

1. Begin by selecting an area of the photograph that you want to copy and use to cover the unwanted elements. An irregular selection will work better than a geometric one because it will blend more smoothly.

2. Feather the selection. This will give it a softer edge, which will also help the selection blend well.

3. Use the copy and paste commands to create a new object layer from the selection.

4. Rotate this new object, if necessary, and position it on top of the unwanted objects. Using your rotation and resizing tools, try to arrange it so that areas of similar tonality are next to one another for smoother gradations.

5. Repeat the process of copying and pasting selections until you've covered the unwanted objects.

6. Merge all of these new objects together with the background.

7. If there's a noticeable boundary around the work you've done, use selections and the blur and noise filters to fine-tune.

Top left detail: The entire image was sharpened.
Top right detail: Only the kids were sharpened.

Selective Sharpening

Most people use the sharpening tool of their image-processing software to sharpen the entire image. And, unless you use some other technique, Unsharp Mask and other sharpening tools will affect everything in the image; they'll sharpen film grain in scanned images, digital noise, JPEG artifacts and other image defects. Frankly, there's really no point in sharpening everything in a photo. If out-of-focus areas and skies, for example, are included in the sharpening effort, then pesky image defects can be magnified. Here's a better procedure.

1. Decide what parts of the photo really need to be sharpened to bring out the inherent sharpness of the image.

2. Select the areas to sharpen.

3. Apply Unsharp Mask and it will affect only the selected areas. Let the unselected areas stay the way they are.

Cloning Straight Lines

Sooner or later, most photographers run into a situation where they need to clone across a straight line, such as across a window or even the horizon. When they try it, the line never stays straight.

1. Move your cursor to the line and set your cloning point directly on the line. As a reference, use a point on your cursor/cloning tool, such as the center of the cloning brush, the tip of the cloning icon, etc.

2. Move the cursor to the place where you need to clone over. Use the same reference point on the cursor to line up a spot where the line must go.

3. Start cloning. Don't change your starting point if it lines up. If it doesn't, undo and try again, readjusting where you line things up at the start.

Dealing with Burned-Out Areas

A difficult challenge comes from an image that has areas that are so bright that there is no detail. In some photos, this is just "drama," but in others, it's distracting. A good way of dealing with this is to add some texture to the area, texture that can be adjusted and will look more natural. Here are two ways to do this; both take a bit of practice to make them work consistently.

Clone texture: If your cloning tool can be set to a lower opacity, do so and clone in some light texture from surrounding areas. In the image of the anhinga in Florida, the reflections on the water had no detail. Texture was added by lightly cloning from the water on the right side of the photo.

Or... add noise: Select the burned-out area, feather the selection and use the filter, Add Noise, if your program has it. Adjust the level of the noise, then the brightness of the area, until it looks natural.

Before **After**

Bright reflections on the water were overexposed and had no detail. Texture was added by lightly cloning from the water on the right side of the photo.

Darken an Overexposed Image

It's disappointing when you get your pictures back and discover that some of your favorite shots were incorrectly exposed. Fortunately, with the computer you have tricks to fix exposure problems. Here's the approach for an overexposed (too light) image.

1. If the whole image needs adjustment, copy and paste the entire photo as a new layer and move on to step 3. To fix certain areas only, select those areas and go to step 2.

2. Soften or "feather" the selection edge by a few pixels, then use the copy and paste commands to create a duplicate layer on top of the original. The rest of the steps will be applied to this new top layer.

3. Go to the layer properties controls and select the multiply mode for this layer. You'll see the density of your image dramatically increase.

4. Reduce the opacity of this layer, if necessary, until you get your desired density—we chose not to here.

5. Merge the two layers. For exposure fine-tuning, you might try adjusting the image's levels or brightness and contrast before merging the layers.

Lighten an Underexposed Image

You might be amazed at the details that lurk in the shadows of your darkest exposures. We started with an evening street scene that had some graphic potential, but a lot of dark, underexposed areas.

1. Using whichever selection tools work best, select the area you want to brighten and recover details from, or choose the entire photo if it all needs lightening. We selected the dark buildings, leaving out the clock post, sky, and other brighter details.

2. Feather the selection edge by a few pixels, then copy and paste the selection in as a new layer.

3. In the layer properties controls, choose "Screen" mode.

4. You'll see a change right away. If the effect isn't enough, copy and paste this layer on top. This will increase the effect with each new copied layer. We did this a number of times until the exposure looked good.

5. Some areas may not have been exposed enough to have any detail. That was the situation with our image—the buildings along the right edge were just too dark. We cropped those areas out of the image.

There are many different ways to add border effects to your images.

Trendy Edges

Getting a cool edge treatment on your photo is a great way to finish an image for display. Many programs, from Microsoft Picture It! to Extensis PhotoFrame, offer a range of edge effects. You can even make your own. Here are several ways to do it.

Use a hard-edged paintbrush and paint an irregular edge with white.

Or… do the same with black.

Or… draw a funky edge around the outer part of the entire photo with the freehand selection tool. Invert the selection, then fill with white.

Or… use layers and erase bits of the edge with a hard-edged eraser tool.

Or… use layers and a layer mask—paint out the edge with the layer mask. This allows you to go back and readjust it as needed.

After applying the technique to lighten underexposed areas, the finished image shows detail in building facades.

Seeing in Black and White

Create striking monochromatic images from your color digital photos.

By Ibarionex R. Perello

Black-and-white images always have held a special place in photography. Although color photographs comprise the majority of the images that are created and printed, a monochromatic print produces a much different reaction than does a color version of the same scene.

There seem to be as many ways to derive a black-and-white image from a color file as there are photographers. Each has benefits and drawbacks. Regardless of whether you're a casual or serious photographer, you'll find a variety of ways to explore the wonderful world of black and white. While the following techniques can be applied in almost any image-processing program, specific references are based on Adobe Photoshop.

The Power of Monochrome Images

One of the virtues of black-and-white photography is its apparent ability to render a scene to its basic elements. Without the distraction of color, a monochromatic image is judged on its composition and range of tones. While compositional rules apply equally to color and black-and-white photographs, the emphasis on tonality produces the uniqueness of a monochromatic image.

A strong color image can produce an equally vibrant black-and-white photo. Depending on which color channel is emphasized (red, green, or blue), the Channel Mixer can enhance or reduce details of your original image, including skin tones and textures. For the final image, a greater percentage of the green channel is chosen along with smaller percentages of red and blue.

A black-and-white image isn't merely about the colors black and white, but the varying shades that lay between the darkest and brightest elements of a scene. A challenge that you'll encounter when shooting a scene is how individual colors translate to monochrome. The ability to evaluate a scene for tones rather than color comes with time and practice. Blues and yellows will be rendered as dark gray and light gray, respectively, because the camera is recording the varying degrees by which individual colors reflect light. Red and green, which look markedly different in a color image, appear as similar shades of gray because they reflect virtually the same amount of light.

Shoot in Black and White

If your camera includes a black-and-white capture mode, one of the easiest ways to create a monochromatic image is in-camera. Select this option and the image that you take and that you evaluate on the camera's LCD screen will be monochromatic. This is an indispensable learning tool that helps you make the transition from color photography simple.

When the digital camera takes a black-and-white photo, it still utilizes the red, green, and blue pixels on its CCD, creating an image that has three identical grayscale channels. By shooting with the digital camera's black-and-white mode, you quickly get a sense of how individual colors translate to black-and-white. You'll also learn how contrasting tones can become the key element in a photograph.

Simple Conversion Techniques

As you become more comfortable with evaluating a scene, you may prefer shooting your images in color and selectively converting some to black-and-white using your image-processing program. This not only gives you the option of creating both color and black-and-white photos, it also teaches you to assess what images translate better to monochrome. There are several ways to easily make the change, as well as advanced techniques that provide greater control.

One quick way to get black-and-white photos is with the Saturation tool in your image-processing software. In Adobe Photoshop, go to Image > Adjustments > Hue/Saturation, and move the Saturation slider to the extreme left, eliminating all color data. The result is a black-and-white image in which the red, green, and blue channels are identical. While easy, it may not provide the best image possible. You have no ability to adjust color channels for more control.

Another quick method calls for converting the RGB image file to grayscale. In Photoshop, go to Image > Mode > Grayscale and convert the open file into a monochromatic image by discarding the

You can easily convert an image to black and white using the Saturation control. The downside is that you have no adjustments for the color channels.

color information. The resulting file is created primarily from the green channel, with less information from the blue and rod channels.

The RGB image is made up of three black-and-white channels—red, green, and blue—and each channel renders the scene differently. You could see the difference if you shot a scene in black-and-white through a red, a green and then a blue filter. The red filter would likely produce a more contrasty scene than the green filter, while the blue filters lighten expansive elements that are dominantly blue, such as water and skies. The blue filter also may reveal electronic noise produced by the CCD.

Converting Images Using Color Channels

Photoshop's Channel Mixer (Image > Adjustments > Channel Mixer) affords great control over the creation of black-and-white photographs. When the Channel Mixer dialog box is open, click on

Individual color channels can look markedly different from each other in black and white. This is because color values that match the color channel you've chosen will appear lighter. For example, in the red channel the tones that were red become lighter. In this example, we found that the red channel displayed the best detail; however, it will vary from image to image.

Red channel

Green channel

Blue channel

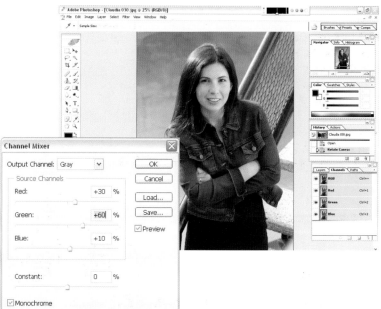

The Channel Mixer offers ample control for converting a color photo into black and white. Adjusting the individual color channels allows you to make custom adjustments for each image. An effective monochrome photograph can be created by using a combination of all three color channels.

the Monochrome option at the bottom of the window; then adjust the red, green and blue channels to vary the tone and contrast of the image. Colors close to those of the filter will appear lighter and thus increase or decrease the contrast between them and other tones. This can be a significant advantage when you want to increase the contrast between two colors that appear close in tone. A red flower against a pattern of green leaves will have a more dramatic contrast if the red channel is emphasized over the green, for example. This is because the red flower will be lightened while the green will darken, thus increasing the contrast.

The default setting applies 100% to the red channel. However, you can change this amount and increase the percentage to the green or blue channels, adjusting the strengths of each channel to emphasize certain tones that are important to your image. If you have a strong red element in the scene that you want to render as a dark tone, you would increase the percentage of the green channel, for instance.

While that seems counterintuitive, remember that if you emphasize the red channel, the red lightens the scene. The same goes for green colors if you emphasize the green channel and blue for the blue channel.

Lastly, make sure that the sum of all three channels doesn't exceed 100% if you want to keep the exposure consistent with the original. Higher numbers will result in a brighter image, and lower numbers will darken a photograph.

Fine-Tuning Images

The initial conversion of a color image into black-and-white still may result in an image that's flat and lacks punch. It's important to check black and white points in Levels and Curves to make adjustments to contrast. Such enhancements are needed to produce the look you've come to expect from striking monochromatic prints.

Begin with Levels, which includes a histogram that reflects the entire tonal range of your image. By adjusting the black and white point indicators, you can establish the darkest and brightest points of the image. A strong black-and-white image requires establishing a solid black and solid white point (unless, of course, your image consists of only gray tones).

Adjust both the black and white point indicators to the extreme edges of the histogram. If you want a natural-looking image, don't bring them in too far; if you do, the image will suffer from clipping, which results in the loss of the highlight and shadow details. Even with a slight adjustment, you'll likely see an improvement in the overall contrast of the image.

If you want to increase the contrast even further, the best tool is Curves. The Curves control has a line that runs diagonally through the graph. By creating a slight S-curve adjustment and bringing the lower portion down and the higher part up, you'll increase the contrast with minimal loss of detail in the highlights and shadows. The more dramatic the S curve, the stronger the contrast will appear.

Digital Color-Correction Filters

Use the idea of traditional color-correction filters to get better images from image-processing software.

By Rob Sheppard

The original photo (left) has a cold, slightly blue color cast from the indirect sunlight illuminating the scene. The blue color cast was removed with a warm "digital filter" effect.

Color is a tricky thing. Our eyes see it differently, depending on the light, surrounding conditions, contrast and so forth. Then the camera—film or digital—sees color in another way. That's not always bad. Sometimes a film's interpretation of colors can be quite effective. Professional photographers have long known this, and they match up their film and subject accordingly. But sometimes there's a disconnect of sorts. The color our camera records just doesn't look right to our eyes.

Usually, this is when the color of the light (such as blue on overcast days) creates color casts that we find unpleasant. Color casts also can result from the scanning process or a digital camera's white-balance bias. Regardless of the cause, unpleasant color casts generally need to be corrected. I say generally because sometimes there are creative or expressive reasons for color casts.

There are a number of options for correcting unwanted color shifts, depending on your software. I'm not going to delve into the pros and cons of any of them. They all work—at times, and they all don't work—at times. It just depends on the photo. I have a color-correction technique that I really like, which works quite well in many color-cast situations. It's a more intuitive photographic technique than many of the more computer engineer-oriented tools (such as color correction by Curves). It's actually based on the traditional photographic technique of using color-correction filters.

In the past, photographers would often color-correct for the light by using pale-colored filters in front of their lens (or the enlarger, in the darkroom). The filter for a camera, for example, would be the opposite of the color that needed correction in the scene, such as a magenta filter in front of the lens when shooting under the greenish light of fluorescent tubes.

For this technique, you need to have an image-processing program that uses Layers and allows the Layer modes to be changed. Both Photoshop and photoshop Elements will work. Here are the steps:

1. Add a new layer over your image.

2. Examine your image to get an idea of its color cast. Look at whites, grays and blacks especially. Use your Color Selection tool—for example, the eye-dropper—to grab a sample so you can see it isolated from your photo.

3. Choose a color that is the comple-ment of the color cast. You don't have to be precise here, but use these color opposites to help: yellow/blue, green/magenta and red/cyan. Load that color into your Color palette (on many programs, this will be the fore-ground color).

Step 3: Once you've identified the color cast use the Color Picker to select its complement.

4. Fill the blank layer with the color cho-sen in step number 3. You may won-der why I didn't suggest creating the blank layer now. I find that with the work order listed, you're less likely to get frustrated because you fill the photo with color instead of the layer.

Step 5: Choose Color as the Layer Mode.

5. Change the Layer mode to Color. You can experiment with other modes, but I've had the most consistent results using Color.

6. Reduce the opacity of the layer to between 3% and 20% until the color cast is mostly gone (this is totally vari-able and can be changed as you go).

7. Use Hue/Saturation to change the hue of this "color-correction filter" layer until the photo looks right.

8. You can also continue to adjust the layer opacity, even to the degree of changing how much certain parts of a layer affect the underlying photo by using a Layer mask or the Eraser tool at less than maximum.

This technique can be used to both remove and add color casts. For example, you can remove the blue of a shadow or add warmth to an image for a sunset shot. You may find you can use a color again and again for certain adjustments. Make a new image file and file it with that color so you can save the color for later.

Color Correction and Control

Use these tips to gain control over the colors in your photographs.

Text by Tim Grey, Photography by Rob Sheppard

Color is a key component of most of our photographs. When it looks wrong, even the best shots are never satisfying. Off-color hues, distracting color casts and more can get in the way of our appreciation of any image. In addition, inaccurate "memory colors" will make the image look wrong to the viewer. A memory color is one that's familiar to most people through everyday experience. For example, we all know the yellow of a banana, the red of a fire truck or the green of grass; we expect such colors to be accurately rendered.

Besides achieving correct colors, you also must get the desired color. People tend to respond more to warm colors—reds, oranges, yellows—so many photographers like to shift the overall image balance toward those hues. For some subjects, such as a winter landscape, you may prefer to "cool" an image to help convey what it felt like to take in the scene.

Let's explore some of the many techniques and tricks you can use to control the color in your images. The previous article provided some useful techniques, but there are others as well as, including slightly different approaches to solving similar problems. The following are some of my own favorites.

Variations

Many imaging-processing programs, including the Photoshop and Elements series, include a Variations feature for adjusting color balance (as well as saturation and brightness) in your images. While Variations provides a preview-oriented method for adjusting the color within your images, I consider it a learning tool more than an adjustment tool. It helps you gain a better understanding of how shifting the color balance in a particular direction will affect the overall image, but it doesn't offer quite the flexibility I prefer.

When you use Variations in Photoshop or Photoshop Elements, you can see a variety of possible adjustments on your screen at once.

Color Balance (above) and Solid Color (below) allow you to adjust the overall color in an image.

The concept of Variations is that you're able to choose the best among a group of different-colored thumbnail images. Many programs have a slider to control the intensity of variation between images. Start with a relatively high setting when you need to make stronger adjustments, but reduce the setting as you get to the point of fine-tuning the color in the image.

Color Balance

Available in Photoshop (and some other brands of software) but not in Photoshop Elements, the Color Balance control is the most basic method for correcting the overall color in your images. It allows you to adjust the balance between opposite primary colors—red versus cyan, green versus magenta, blue versus yellow—by moving a slider representing each color axis. In order to fix a magenta color cast, for example, shift the color balance toward green. With a bit of experimentation, you'll soon find the entire process to be easy and convenient.

For programs that don't offer a Color Balance control, you can use Levels to produce the same results by moving the middle-tone sliders for each of the individual color channels.

When using Color Balance, I recommend swinging each slider through the extremes to give you a better idea of how the color shifts affect the many colors within your image. It also makes it easier to gain perspective on where that perfect color balance will be found. Gradually reduce the swings as you zero in on the best setting for each slider.

Hue/Saturation

The Hue/Saturation control (available in most programs) is often used merely to bump up the intensity of colors (or tone them down) within an image, but this adjustment tool packs much more power.

The key to Hue/Saturation is the separate color drop-down menu, which allows you to adjust a specific range of colors. If skin tones in an image look a bit too ruddy, select Reds from the menu and reduce its saturation. If the sky looks too blue, select Blues and shift the Hue slider toward cyan, producing a more natural look.

Gray Eyedropper

When you have an area of your image that should be perfectly neutral, finding the right color balance visually can be a challenge. The gray eyedropper found in the Levels and Curves dialog boxes offers a quick and easy solution. Select the gray (middle) eyedropper; then click on a gray area in the image. The color balance will automatically be adjusted so the area you clicked is absolutely neutral. Hence, other colors should also be more accurate. This is a remarkably quick way to produce a thoroughly neutral image, but the trick is finding just the right pixel on which to click.

It's also important to consider whether you want the intended area to be truly neutral. Just because something is gray doesn't mean it should appear gray in the image. If you photograph an 18% gray card illuminated by a colorful sunset (with a yellow/red shade of light), it won't (and shouldn't) appear gray in the final image.

Solid Color

The Solid Color adjustment layer (not available in Elements programs) allows you to add a wash of color to the image, either to create a different mood or to off-set an undesirable cast. The first step is to add a Solid Color adjustment layer. (The command in Photoshop is Layer > New Fill Layer > OK.) When you do so, the Color Picker dialog box will appear. Select the color you think will produce the desired effect (you'll be able to change the color later).

Click OK, and then change the blending mode of the layer from Normal to Color using the drop-down menu found at the top of the Layers palette. This will cause the Solid Color adjustment layer to affect only the color of the underlying image, but the effect will be too strong initially.

The gray eyedropper can be used to automatically adjust the color balance of an image to neutral.

Adjust the Opacity setting found at the top of the Layers palette to produce a more subtle effect.

If you'd like to change the color being added to the image, simply double-click on the Solid Color adjustment layer to bring up the Color Picker dialog box. Select a new color, watching the change in the image to help make your decision.

Average Color Cast Removal

Create a duplicate copy of the image layer by dragging it to the New Layer icon at the bottom of the Layers palette. With this duplicate image layer active, choose Filter > Blur > Average. This turns the layer into a solid color, representing the average color value of all the pixels. Apply the opposite of this color to offset the color cast, so select Image > Adjustments > Invert. Change the blending mode from Normal to Color in the Layers palette, and the color in the image will be shifted toward the opposite of the color cast. The effect will be too strong, creating an intense color cast, so reduce the Opacity at the top of the Layers palette until the color cast has been neutralized effectively.

Painting a Color Fix

At times, you may find you want to adjust the color of a specific problem area of an image. Using a few simple settings, you easily can paint a different color into those areas. Start by creating a new empty layer by clicking the Create New Layer button at the bottom of the Layers palette. Change the blending mode from Normal to Color at the top of the Layers palette, and select the Brush tool from the Tools palette.

You're now ready to paint new colors into particular areas of your image. With the Brush tool active, hold the Alt/Option key and click on an area of the image that has the color you want to duplicate, which will set this color as the foreground color. Using a soft-edged brush, paint over the problem area of the image, watching the color magically change.

Besides painting with colors found within the image, you can click on the foreground color on the Tools palette to bring up the Color Picker dialog box and choose any color with which you'd like to paint, offering maximum control over the colors in the image.

Create a new layer, set the mode to Color, and paint over the areas of the image that need color correction.

Levels Simplified

Levels is a key image-processing adjustment tool.

By Rob Sheppard

Nearly every advanced image-processing program includes Levels, a useful tool for adjusting the brightness and contrast of a photo. It's one of the first adjustments one should make to an image. Levels includes a histogram, a graph of the pixels from black to white. You don't have to know anything about graphs or pixels in order to use this feature, however.

There's no standard location for Levels in the menus of various programs. You may have to check the Help function to find Levels in your image-processing software.

Fundamentals of Levels

- This is an important basic image adjustment tool for photographers.

- It allows a high degree of brightness and contrast control.

- You can adjust shadows, highlights, and midtones—preferably in that order—separately.

- Auto Levels is an automated adjustment that works sometimes, but can start you in the wrong direction.

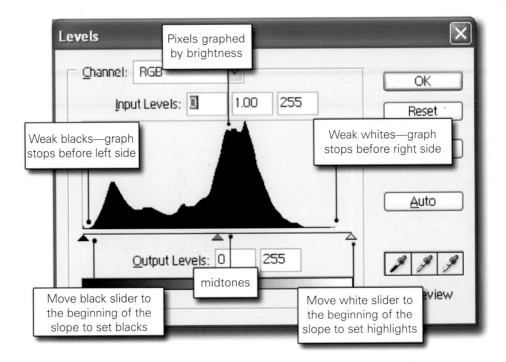

Levels

Channel: RGB

Pixels graphed by brightness

Input Levels: 0 1.00 255

OK

Reset

Weak blacks—graph stops before left side

Weak whites—graph stops before right side

Auto

Output Levels: 0 255

midtones

Move black slider to the beginning of the slope to set blacks

Move white slider to the beginning of the slope to set highlights

Using Levels

The histogram plots the numbers of pixels against tonal values (brightness) in the photo. The left side represents the dark parts of the photo and the right side represents the light parts. Begin by looking at the left side; if it shows nothing in the graph and the "hills and valleys" of the graph start much farther to the right, there are no blacks in the photo.

We need to see some data showing up in the black areas, so we start by moving the black slider to the right (to darken shadow areas) until it's right under the start of the histogram data (where it slopes up). That sets the black point.

You can go farther to the right for strong effects, but that's subjective. This first black point is a critical spot for the photograph. Once you make this adjustment, you'll see results immediately. If Levels in your software includes a Preview option, turn it on and off to better evaluate the effect that the change has made.

Even experienced users can become intimidated by the graphic rendition of the photograph in Levels, but once you get into it, you'll see that adjustments are easy to make and you'll get excellent results.

You'll notice a black eyedropper at the bottom right of the dialog box in Adobe Photoshop programs. This can be used to set the blacks "automatically" by clicking it on the area of the image that should be completely black. I don't like the tool, as it tends to be too clunky. It's difficult to hit the best spot for getting the right black, and it rarely gives me the results I like, so I stopped using it.

Next, set the whites. Move the slider on the right side of the histogram towards the center and you'll notice that highlights become brighter. Set the slider below the point where the highlight histogram data ends on the graph. Adjust the white point carefully, as you can quickly blow out the highlights and lose detail in bright areas of the image. There's also a white eyedropper (which I never use for the same reasons I don't use the black one).

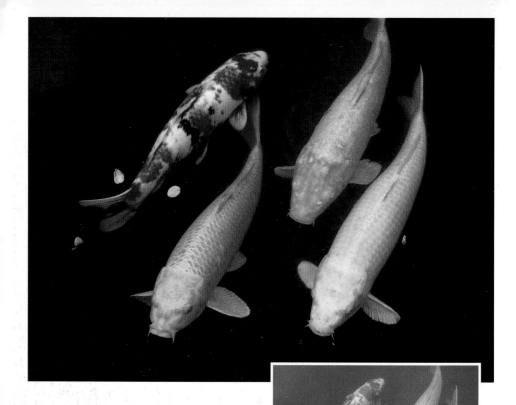

Use the middle slider (gray) to adjust the overall brightness of this adjusted image; this central slider primarily affects the midtones. Watch your tones carefully as you use this control; you may want lots of detail in midtone areas, but too much detail can make your photo seem dull. You generally need some richness in the dark areas for a photo to have some contrast and life. The gray eye-dropper is for color, and is a separate and different adjustment.

These simple adjustments in Levels usually bring a photo into the right range for printing and other uses. You can creatively interpret your photo from this point, making the blacks stronger yet or brightening the light areas. Some photographers try Auto Levels or Auto Contrast options in their imaging software; these can give adequate results, but they're never fully satisfying to me because they're automatic and not based on what you see changing in your image.

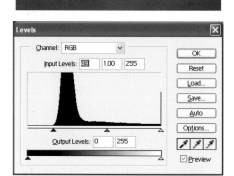

Without solid, rich blacks, a photograph will always look dull and flat. To get a strong black in your image, bring the left Levels slider to the beginning of the histogram data. After some quick adjustments, you can have a much stronger photograph.

Extending Your Range

Increase the dynamic range of your image by combining two photographs.

By Ibarionex R. Perello

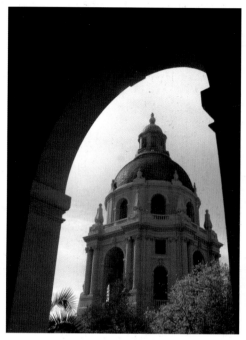

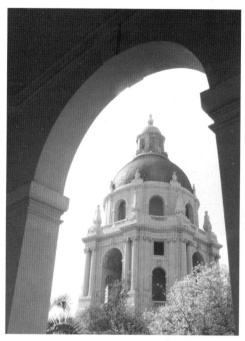

The tonal range of this scene was too great for a single exposure. Exposing for the highlights caused the shadows to lose detail. If the image has detail in the shadows, the highlights are to bright.

When you're photographing a high-contrast scene, a single image may not provide you with your best shot. Whether it's film or digital, your camera is limited in its ability to capture both shadow and highlight detail in a high-contrast scene. If you bias exposure for the highlights, the shadows go black. If you expose for the shadows, the highlights are blown out. Even if you compromise on the exposure, you'll probably lose important details on both ends of the tonal range.

Thankfully, the computer can be used to create an image without having to sacrifice detail. Image-processing software can be used to merge two images of disparate exposures to produce a shot with excellent detail. By combining the properly exposed highlights of one image with the shadow detail of another, an image is created that reveals details throughout the entire tonal range.

For my test, I made sure to mount my camera on a tripod. A stable platform was a must since I needed to merge two different shots of the same scene. A hand-held camera would have resulted in two incompatible images because of slight differences in framing. Next, I took three different exposures of the scene.

The first one provided a normal exposure; the second was underexposed by one stop; the third was overexposed by a full stop. I used the camera's auto-bracketing feature to further reduce the chance that my handling of the camera would change its position. If your camera doesn't have auto-bracketing, take great care not to move the camera when adjusting the controls.

Ulead's PhotoImpact image-processing software offers a great way to merge two shots of disparate exposures to produce a single image with excellent detail. Other software, including some plug-ins, also includes a photo-merging feature. Similar results can be achieved in Photoshop or Elements by combining images as separate layers.

I discovered that the best results came from optimizing the original images before merging them. I used both the Levels and Curves controls to make adjustments to tone and contrast. Once the images were merged, I continued to make adjustments to increase the saturation of the sky and the contrast of the building's exterior.

Regardless of the way you achieve it in the digital darkroom, creating an image with increased dynamic range would have been difficult or even impossible using only the standard methods that were available a few years ago.

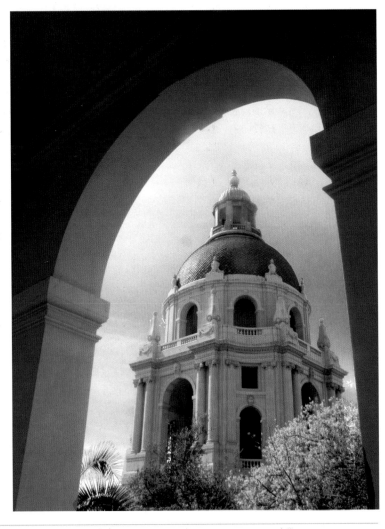

Combining the two images produced a photograph that retained the important details of both shots. The resulting image has good exposure for the sky (highlight) as well as detail in the interior arch (shadow).

index